More Crafty Activities

Over 50 fun and easy things to make

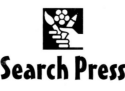

Search Press

First published in Great Britain 2008

Search Press Limited
Wellwood, North Farm Road,
Tunbridge Wells, Kent TN2 3DR

Based on the following books from the
Step-by-Step series published by Search Press:

Collage by Judy Balchin (2002)
Clay Modelling by Greta Speechley (2000)
Beadwork by Michelle Powell (2002)
Decorative Painting by Judy Balchin (2001)
Papermaking by David Watson (2000)
Paperfolding by Clive Stevens (2001)

Text copyright © Judy Balchin, Greta Speechley, Michelle
Powell, David Watson, Clive Stevens 2008

Photographs by Charlotte de la Bédoyère,
Search Press Studios
Photographs and design copyright © Search Press 2008

ISBN-13: 978-1-84448-318-1

Suppliers
If you have difficulty obtaining any of the materials and
equipment mentioned in this book, then please visit the
Search Press website for details of suppliers:
www.searchpress.com.

Printed in China

*The Publishers would like to say a huge
thank you to all the children who
appear in the photographs.*

*Finally, special thanks to
Southborough Primary School,
Tunbridge Wells*

When this sign is used in
the book it means that adult
supervision is needed.

REMEMBER!
Ask an adult to help you
when you see this sign.

Contents

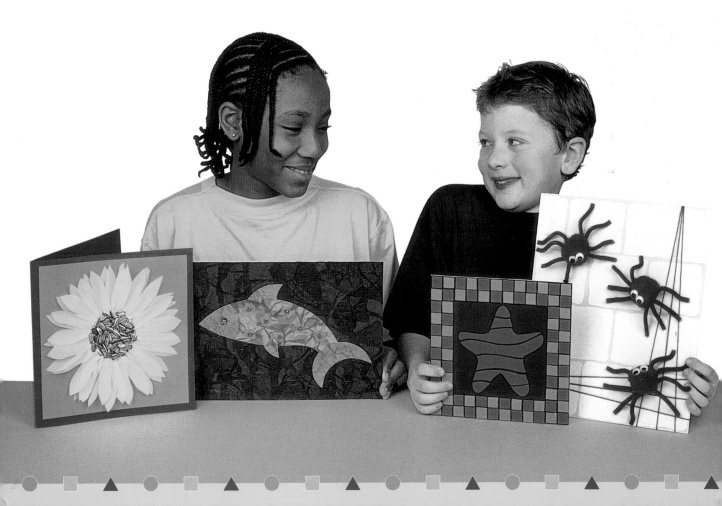

Collage

by Judy Balchin

You have probably been creating collages for years without even knowing it. The word 'collage' comes from the French word meaning 'to stick' and we can all remember creating pictures by sticking paper shapes on to a piece of card.

Over the years, many artists have used collage in their work. Matisse was a very famous French artist. As he got older, he found painting quite difficult, so he started tearing and cutting up pieces of coloured paper to make his pictures.

Beautiful collages were created by a lady called Mary Delaney who lived in the eighteenth century. She was an expert needlewoman and made delicate collages using plant life as her theme. She did not start making her collages until she was seventy-two – a craft for all ages!

You may think that only paper is used in collage, but that is far from the truth. Twentieth century artist, Georges Braque, used very unusual materials in his work. He introduced imitation wood paper and fabric to his pictures. Perhaps some of the most unusual collages come from an artist called Kurt Schwitters, who made pictures using rubbish that he found in his city life, such as tickets, rags, advertisements and newspaper.

You don't have to be particularly artistic to create a collage. It really is a question of colour and balance. Pieces can be moved round and played with until you are satisfied with the arrangement, and then simply stuck down.

If, like me, you are a hoarder, then this section is definitely for you. I've always been drawn to brightly coloured pieces of fabric, coloured papers, ribbons, sequins and jewels. I must admit to having boxes of bits hidden here and there around my home. This section has given me the excuse to get all those boxes out. Felt, foil, feathers and foam; leaves, seeds and even plastic and polythene can be used for collage. The list is endless. A walk along a beach or in the countryside can provide you with a wealth of material to use. Alternatively just look around your own home and see what you can come up with.

So there you sit with your boxes of goodies. Perhaps the next question is what to make a picture of. As you work through this section, you will come across collages of butterflies, fish, aliens, spiders, flowers, fairies and even an Egyptian god. By the time you have completed all the projects in this section, you will have created a collage art gallery. Perhaps, more importantly, it will have inspired you to create your own collages using your interests, hobbies or even your favourite colour as a theme. Good luck with your sticking!

Sea Scene

A third of the surface of the world is covered by water. These seas and oceans are full of life. Most fish live in the upper part of the seas, down to a depth of 600m (2000 feet). Below this lurk strange deep-sea fish living in the darker waters. In this project we create the movement of water using layered and scrunched tissue paper. Our brightly coloured fish dives across the collage, its jewelled decorations catching the light.

YOU WILL NEED

A4 piece of thick card
Thin white card
Coloured tissue paper
Watered down PVA glue
Paste brushes
Scissors
Pencil
Coloured gems

1 Paste a section of your base board generously with some watered down PVA glue. Lay a piece of scrunched up tissue paper on to the glue and dab it with a paste brush until it lies flat, but with scrunched creases, as shown. Overlap the next piece of tissue paper slightly and continue in this way until the board is covered.

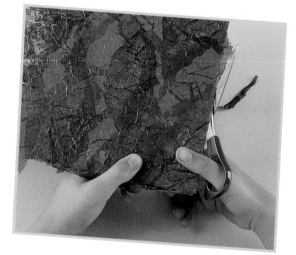

2 When the board is dry, use scissors to cut off the overhanging tissue paper.

3 Transfer the fish pattern on page 29 on to thin white card. Page 26 shows you how to transfer a pattern. Cut the fish shape out. Scrunch and glue pieces of tissue paper in a lighter colour over the surface of the card fish.

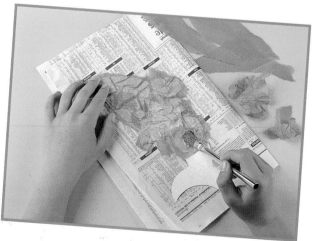

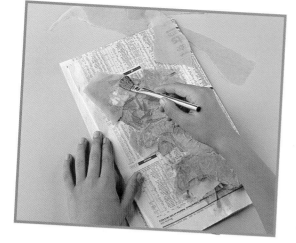

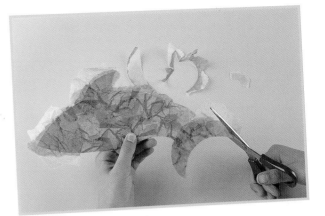

 4 Use a different coloured tissue paper to cover the head, tails and fins. Scrunch and glue as before.

5 Tear circles of tissue paper and stick them on to the body section. Leave to dry. Cut off the overhanging tissue paper.

 6

Glue the fish to the base board. Glue one coloured gem to each spot on the fish's body. Glue a gem in place for the fish's eye. You can glue a smaller gem on top to make a realistic pupil for the eye.

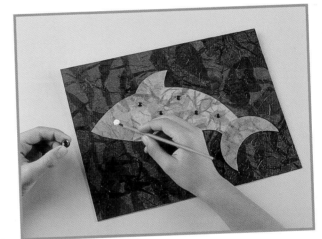

FURTHER IDEAS
Make a fish bowl filled with smaller fish made in the same way.

Butterflies

The beautiful colours of the butterfly inspired this collage. There are about one million known kinds of insect. A lot of them use their shape and colour either to attract a mate or to scare off an enemy. How many brightly coloured insects can you think of? Multicoloured sequins are the perfect decoration for our butterfly collage. The wings shimmer against the dark background, giving a real feeling of movement.

YOU WILL NEED

Dark-coloured thick card, 8 x 24cm (3 x 9½in)

Thin card for template

Thin coloured card

Coloured pipe cleaners

Coloured sequins

Pencil

Scissors

PVA glue

 Make a template of the butterfly pattern on page 30. Page 26 shows you how to make a template. Draw round the template three times on thin coloured card. Cut out three butterflies.

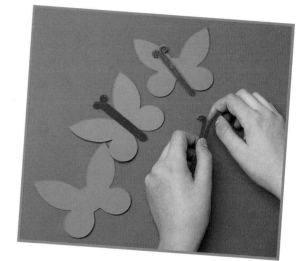

 To make the butterfly bodies and antennae, cut an 18cm (7in) length of coloured pipe cleaner for each butterfly. Bend them in half and curl the ends as shown. Glue one body down the centre of each butterfly.

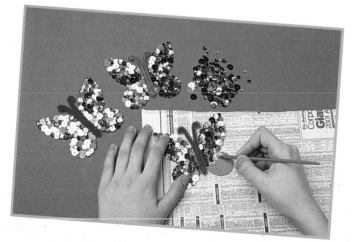

3 Glue coloured sequins on to the card wings, overlapping them slightly so that the card is completely covered.

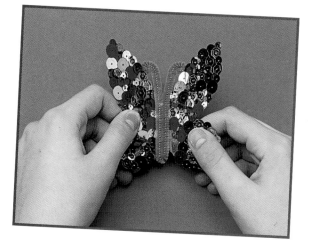

 4 Bend the wings upwards slightly either side of the body.

 5 Turn the butterflies over and run one line of glue down each body section.

 6

Press the butterflies on to your dark-coloured thick card so that they overhang the edges of the card.

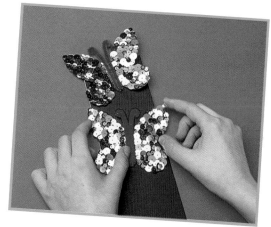

FURTHER IDEAS
Create a shimmering dragonfly using shiny fabric for the wings and beads and gems for the body.

Roman Mosaic

The Romans loved to decorate their large city villas. Though they were often quite plain on the outside, inside could be sumptuous. They used small pieces of coloured stone, called 'tesserae', to cover their floors, placing them so that they formed intricate patterns. These were called mosaics. This project shows you how to make a mosaic starfish collage using small pieces of coloured foam. Don 't worry if all the pieces are not exactly square – your collage will look more realistic if they are slightly irregular.

YOU WILL NEED
20cm² (8in²) square of thick black card
Three sheets of coloured foam
Thin card • Scissors
PVA glue • Pencil
Ruler

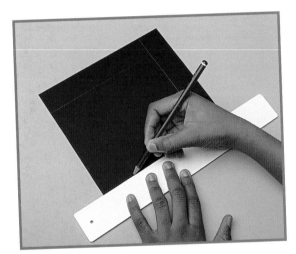

1 Use a pencil and ruler to draw a line 33mm (1¼in) from each edge of your thick card, to create a border.

2 Cut 1.5cm (½in) strips from two pieces of different coloured foam. Mark 1.5cm (½in) sections all along the strips, and cut them into squares.

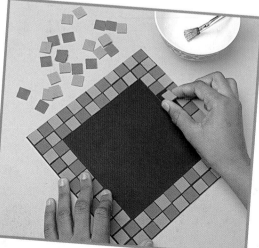

3

Glue a row of foam squares around the edge of the black card, using alternating colours. Glue a second row of squares inside the first row as shown.

4 Photocopy the starfish design on page 27 on to thin card and cut it out to make a template. Place the starfish template on a coloured piece of foam and draw round it with a pencil. Cut it out.

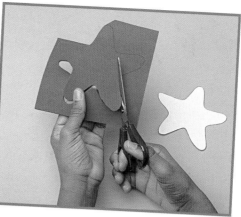

Ask an adult to help you use the photocopier.

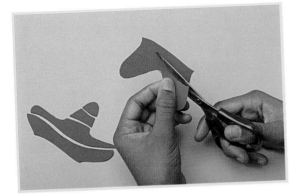

5 Draw wavy lines across the starfish with a pencil. Cut along the wavy lines. Arrange the cut pieces into a starfish again in the middle of your mosaic border.

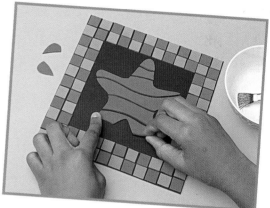

6 Glue the pieces down.

FURTHER IDEAS
Make a dolphin picture in a mosaic frame.

Creepy Crawlies

Some people are frightened of spiders, so this project could be a bit of a challenge! They are, however, fascinating creatures. Did you know that most spiders have eight eyes and that they taste through their feet? Some large spiders can live to twenty-five years and some South American varieties actually eat birds! What other amazing facts can you find out about spiders? These colourful pompom spiders with their pipe cleaner legs and wobbly eyes aren't quite so scary, so have fun creating this creepy crawly collage.

YOU WILL NEED

Thick card, 30 x 25cm
(11¾ x 10in)
Textured wallpaper
Coloured pompoms
Coloured pipe cleaners
Coloured wool • Plastic eyes
Scissors • PVA glue
Sticky tape

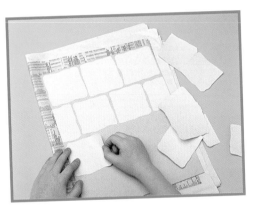

 1 Cut out irregular paper stone shapes from wallpaper. Arrange them on your thick card base board to look like a stone wall. Some of the end 'stones' will have to be cut in half to fit. Glue them on to the base card and leave to dry.

2 Turn the base board over and tape a length of wool to the top right-hand corner. Wrap the wool round the card to create a fan-shaped web on the front. Tape the end of the wool to the back of the card to secure it.

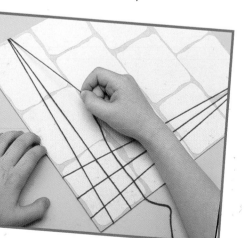

3 Wrap another length of wool across the bottom of the card in the same way, and tape the end at the back to secure it.

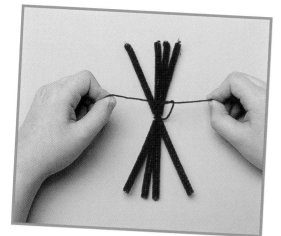

Cut two pipe cleaners in half. Tie the four pieces together in the middle with a piece of wool to make the legs of the spider.

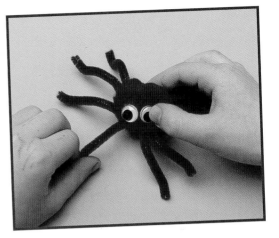

 Bend the legs as shown. Glue a pompom body to the place where the legs meet. Glue two plastic eyes on to the pompom. Make three spiders in the same way.

 Glue two spiders on to the stone wall and one in the centre of the web.

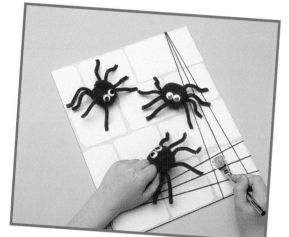

FURTHER IDEAS

Make centipedes from pompoms with snipped felt strips for legs, glued on to a background of paper leaves.

Sunflower Card

This project uses real sunflower seeds to decorate the centre of a paper sunflower. Sunflower seeds, and the seeds of other plants such as the poppy, are edible (unless you are allergic to nuts and seeds!) We grind seeds to spice our food, add them to our breads and cook with them. Oil can be extracted from certain seeds and, of course, seeds are also planted to grow a new crop. Try writing a list of different seeds and what we can do with them.

YOU WILL NEED

Coloured thick card
23 x 46cm (9 x 18in)
Lighter-coloured thin card
21cm (8¼in) square
Coloured crepe paper
Sunflower seeds
Scissors • Ruler
PVA glue • Paste spreader
Pencil • Compasses

 Score and fold the rectangle of thick card down the middle to make a greetings card (see page 26). Glue the square of lighter-coloured card to the middle of the front.

2 Find the centre of the square card by drawing in the diagonals with a pencil and ruler. Set your compasses to 3.5cm (1¼in) from the point to the pencil. Put the point in the centre of the square and draw a circle.

3

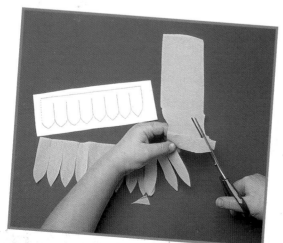

Take two 7 x 50cm (2¾ x 19¾in) strips of coloured crepe paper. Cut petal shapes along one long edge using the pattern on page 28 to help you.

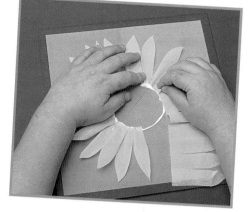

 4

Run a 1cm (½in) line of glue around the outside of the pencil circle. Press the straight edge of the petal strip round the circle, scrunching the paper to make it fit. Complete one circle.

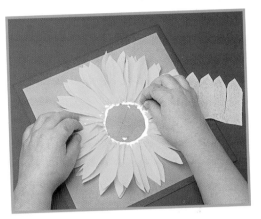

 5

Run another line of glue round the inside of the circle and press the second petal strip round it in the same way.

6

Spread the circle generously with glue, overlapping the base of the petals slightly. Press the sunflower seeds into the glue and leave to dry.

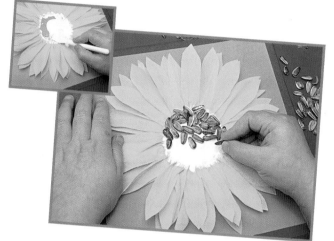

FURTHER IDEAS
Make a bright poppy in the same way, using poppy seeds for the flower centre.

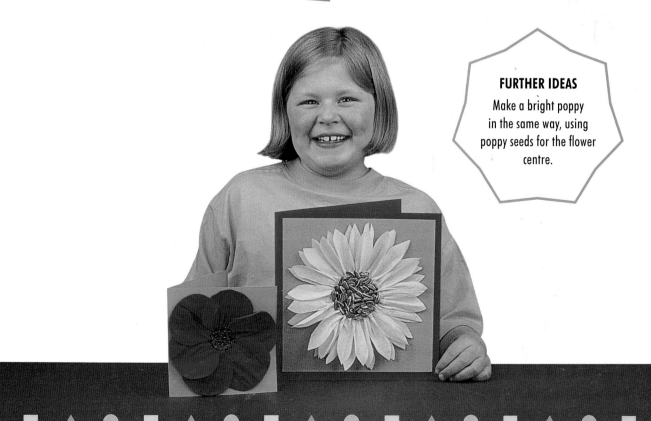

Fairy Card

Every country has its own stories about mythical creatures. Fairies, elves, gnomes, goblins, pixies, leprechauns – how many different creatures can you come up with? Fairy tales have entertained children throughout the world for hundreds of years. These stories are often exciting, sometimes scary and frequently offer a moral at the end of the tale. This project uses shimmering fabric, glittery cord and sparkly gems and beads to create a magical fairy card.

YOU WILL NEED
Coloured card, 18 x 21cm
(7 x 8¼in)
Coloured felt
Shiny fabric • Silver cord
Small gems • Star sequins
Large glittery beads
PVA glue • Scissors
Pencil

 1 Score and fold the coloured card lengthways to make a greetings card (see page 26). Transfer the face pattern on page 27 on to felt (also see page 26). Cut it out and glue it to the front of the card.

2 Glue two small gems to the face for eyes. Squeeze a blob of glue on to the top of the circle. Crumple some silver cord and press it into the glue to make hair.

3 Make wing templates using the pattern on page 27. Draw round them on shiny fabric and cut them out. Squeeze some glue just below the head and press the ends of the wings into place.

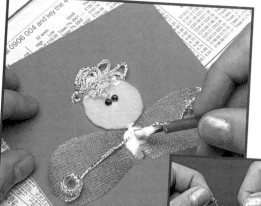

4

Cut a 12cm (4¾in) length of silver cord. Thread each end with a bead and knot to secure. Place the piece of cord across the wings and glue it in the middle. This will make the fairy's arms.

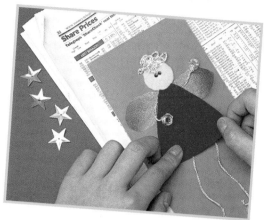

5

Cut a 30cm (11¾in) length of silver cord for the legs. Thread each end with a bead and knot as before. Fold the cord in half and glue the fold just under the arms.

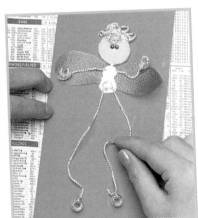

6

Use the pattern on page 27 to make a template of the dress shape, cut it out from felt and stick it onto the card just below the head. Glue a halo of star-shaped sequins around your fairy's head, and one sequin to the dress.

FURTHER IDEAS

Why not make a pixie to go with your fairy card? Put a feather in his cap.

Junk Truck

Everything in nature is recycled. Vegetation and animal remains feed the soil, which in its turn, nourishes new life. We can play our part by recycling rubbish that is not biodegradable, that is, it doesn't rot away. Nowadays there are factories that recycle paper, glass, aluminium cans, car tyres, some plastics, old clothes and lots more. You can create a collage using junk found around your home. Collect plastic, polythene and polystyrene packaging instead of putting it in the bin. Look for paper, string and bottle tops too – you will be amazed at how much junk you find.

YOU WILL NEED

Cardboard box lid
Junk: coloured plastic containers, lids, polythene, string, polystyrene, foam packing and plastic netting
Kitchen foil
Permanent felt tip pen
PVA glue • Scissors

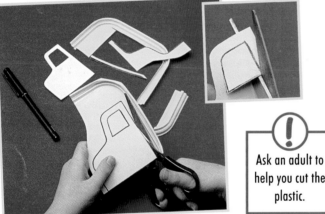

 Ask an adult to help you cut the plastic.

1 Make templates from the pattern on page 28, using the technique shown on page 26. Place the cab template on a piece of coloured plastic and draw round it with a permanent felt tip pen. Cut it out.

2 Cut a piece of coloured polythene slightly larger than the window hole. Glue it on to the back of the plastic so that it covers the hole.

Note To cut the window hole, first cut across the upright bar at the back of the cab. This makes it easier to move the scissors, and will not show when you stick the cab down.

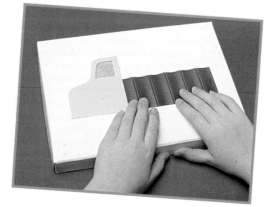

3 Glue the cab on to the box lid. Use a template as before to cut the back of the truck out of coloured plastic. Glue it behind the cab.

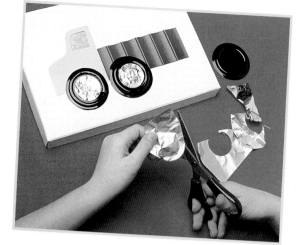

4

Cut three circles of black plastic for the wheels. Cut three smaller circles of foil and glue one to the middle of each wheel. Glue the wheels along the bottom of the truck.

5 Roll a ball of foil and flatten it slightly for the headlight. Glue it into place.

6

Now fill your truck with junk! Cut your bits of junk into small pieces and glue them to the back of the truck.

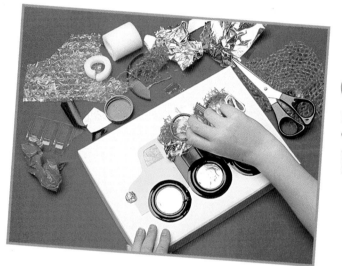

FURTHER IDEAS
Make a junk robot from the plastic tray inside a box of chocolates.

Egyptian God

The Ancient Egyptians believed in many gods. Some of the gods shown in their pictures looked half animal and half human. Anubis had the head of a jackal – a dog-like animal. The Egyptians believed that he was in charge of the underworld. Priests who prepared bodies for burial wore Anubis masks while performing their duties. In this collage, Anubis is shown wearing a sparkling headdress, and standing in front of some sandpaper pyramids.

YOU WILL NEED

Thick coloured card 25 x 23cm
(10 x 9in)
Thin card • Black felt
Sheet of sandpaper
Gold sequin trim
Coloured gem
Scissors • Old scissors
PVA glue • Ruler
Chalk • Pencil

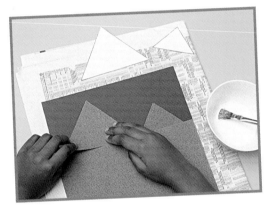

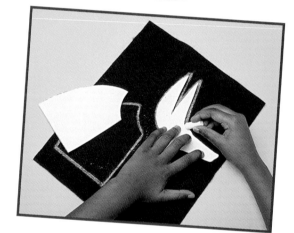

1 Glue a 15 x 23cm (6 x 9in) piece of sandpaper across the lower half of a 25 x 23cm (10 x 9in) piece of thick coloured card. Make pyramid templates as shown on page 26, using the patterns on page 29, and draw round them on the back of another piece of sandpaper. Cut out the pyramid shapes and glue them on the horizon line.

2 Make templates of the Anubis patterns. Lay them on black felt back to front, and draw round them with a piece of chalk. Cut out the felt shapes, cutting along the inside of the chalk lines.

Ask an adult to help you cut the sandpaper, and always use old scissors.

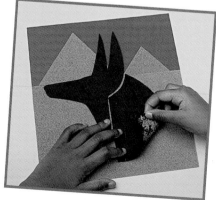

3 Spread the felt pieces with glue and then turn them over and stick them on to the sandpaper background.

20

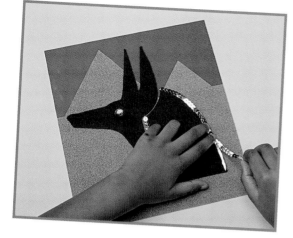

 4

Glue a coloured gem in place for the eye. Squeeze a line of glue down the left-hand and right-hand edges of the headdress shape. Press a length of sequin trim on to the glue.

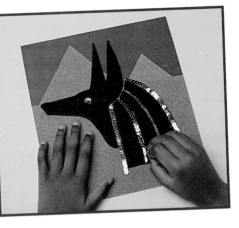

5

Use chalk to draw two curved lines between the sequined edges of the headdress. Squeeze glue down each line and glue lengths of sequin trim in place.

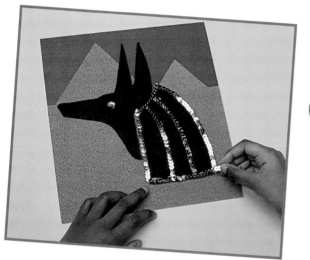

6

Trim the ends as shown. Glue a length of sequin trim along the top and bottom of the headdress. Leave to dry.

FURTHER IDEAS

Make a Chinese dragon using felt and fabric. What other animals can you think of that are connected to certain countries?

Leaf Card

Leaves and plants are very important to our planet. They take in carbon dioxide from the air and give off oxygen which we need to survive. Dried leaves and fruits provide us with beautiful shapes and textures which are ideal for collage work. Just look at the delicate skeleton leaf. You can see clearly the fine network of strands that kept the leaf supplied with water and nutrients. Use an earthy coloured card for this project, as it will really set off these natural forms.

YOU WILL NEED

Thin coloured card
Coloured handmade paper
Skeleton leaf
Dried orange slice • Raffia
PVA glue • Glue spreader
Pencil • Scissors

1 Cut an 18 x 9.5cm (7 x 3¾in) rectangle of thin coloured card. Score and fold it down the middle, as shown on page 26. Measure and cut a 9 x 9.5cm (3½ x 3¾in) rectangle of handmade paper.

2 Tear a small strip from each edge of the handmade paper, to give it a rough-edged look. Glue the rectangle to the front of your card.

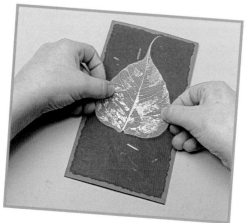

3 Put the skeleton leaf on a piece of scrap paper and spread it carefully with a little glue. Press it gently on to the front of your card and leave to dry.

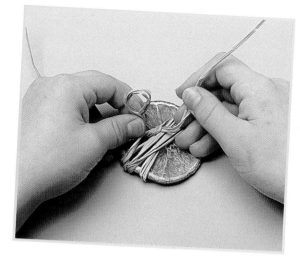

 4

Wrap a dried orange slice with raffia and tie it in a bow at the front. Trim the ends of the raffia using scissors.

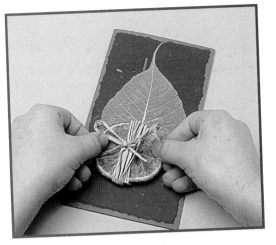

 5 Glue the wrapped orange slice to the card at the base of the leaf.

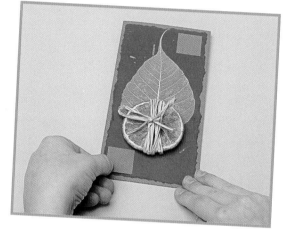

6

Cut two 2.5cm (1in) squares of coloured card and glue them to your leaf card: one to the top right and one to the bottom left.

FURTHER IDEAS
Make a tree with a raffia trunk, paper leaves and card and mustard seed oranges. Add grass made from dried herbs sprinkled over wet glue.

Alien

The Earth is a small planet in a huge universe. The universe is made up of countless planets and stars. Nobody knows how big the universe is or if it has any limits. Do you think there is life on other planets? If you think there is, what do you think these alien life forms would look like? In this project, metal foil is used to create the alien. Backed with colourful planets drifting in a dark sky, this collage is definitely out of this world!

YOU WILL NEED
Coloured thick card
Coloured tissue paper
Thin white card
Thin silver embossing foil
Pipe cleaners • Sticky tape
Coloured and silver sequins
Watered down PVA glue
Paste brush • Ballpoint pen
Pencil • Plate • Cup
Scissors • Newspaper

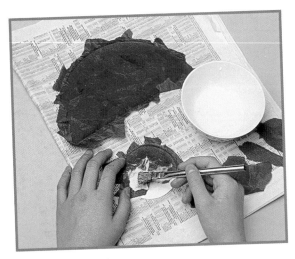

1 Draw round a plate and cup to make a circle and a semicircle on a piece of thin white card. Cut out the shapes. Glue torn pieces of tissue paper over the card shapes and leave to dry.

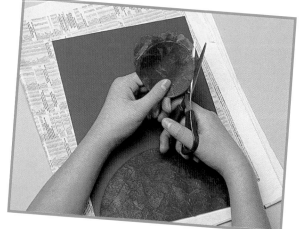

2 Cut off the overhanging tissue paper. Glue the large semicircle to the bottom of a 20 x 30cm (8 x 11¾in) piece of coloured card. Glue the smaller circle to the top right-hand corner.

Ask an adult to help you use the photocopier.

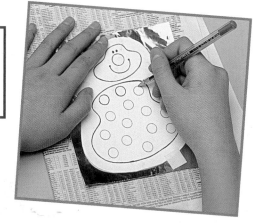

3

Photocopy the alien pattern on page 27 on to paper. Cut round the pattern, leaving space around the edges as shown. Place a piece of embossing foil slightly larger than the pattern on a folded newspaper. Lay the pattern on top and tape it to the foil. Use a ballpoint pen to trace the design through on to the foil. Press firmly.

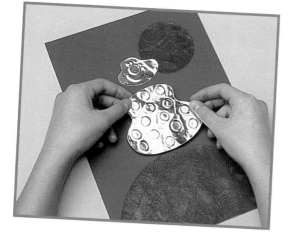

Remove the pattern and cut out the alien head and body from the foil. Turn them over. Glue them on to the planet card.

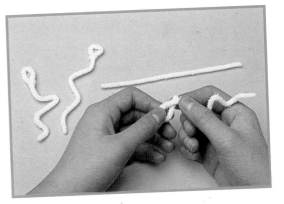

Bend four pipe cleaners into zigzags. Bend one end of each pipe cleaner into a circle to make hands and feet. Twist to secure.

6

Glue the pipe cleaner arms and legs into position. Cut two 10cm (4in) lengths of pipe cleaner to make antennae. Roll one end of each length into a ball. Glue the antennae on to the top of the alien's head. Decorate with sequins.

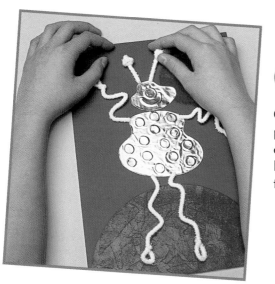

FURTHER IDEAS

Make a rocket collage using silver card, hologram card and sequins. Use decorative floss for the rocket's fiery trail.

Techniques

Making a greetings card

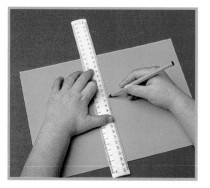
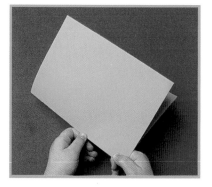

 1 Measure halfway across your card and mark the halfway points at the top and bottom.

 2 Using a ballpoint pen that has run out of ink, and a ruler, score a line down the card between the marks.

3 Fold the card along the scored line to make a nice sharp crease.

Ask an adult to help you to photocopy the patterns.

Transferring a pattern

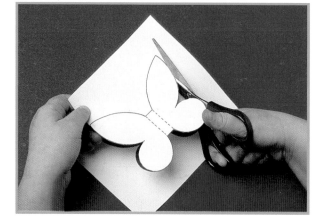
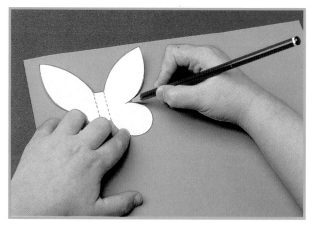

 1 Photocopy the pattern on to thin white card. You can enlarge it on the photocopier if you need to. You can use the photocopy for your project, or you can cut out the pattern to make a template.

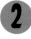 **2** Draw round your template to make the shapes you need for your collage projects.

Patterns

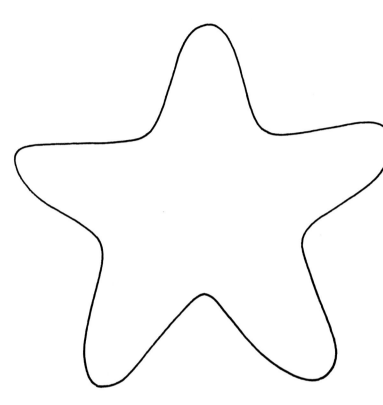

Pattern for the Roman Mosaic featured on
pages 10–11

Pattern for the Alien collage featured
on pages 24–25

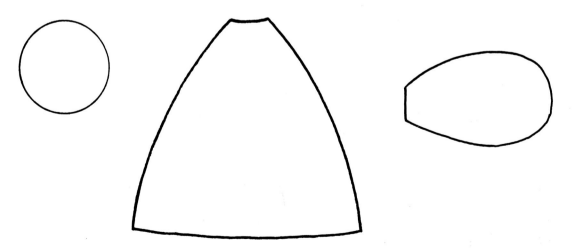

Patterns for the face, dress and wings for the Fairy
Card featured on pages 16–17

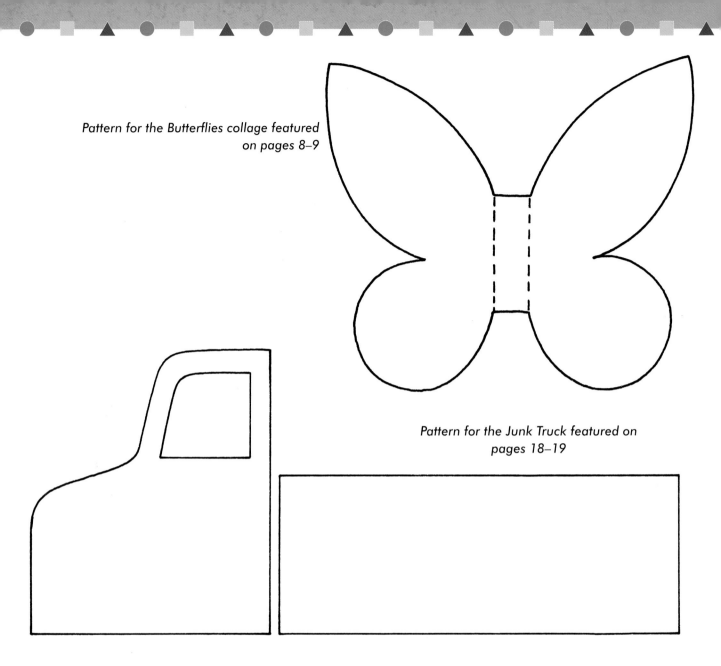

Pattern for the Butterflies collage featured on pages 8–9

Pattern for the Junk Truck featured on pages 18–19

Pattern for the petals of the Sunflower Card featured on pages 14–15

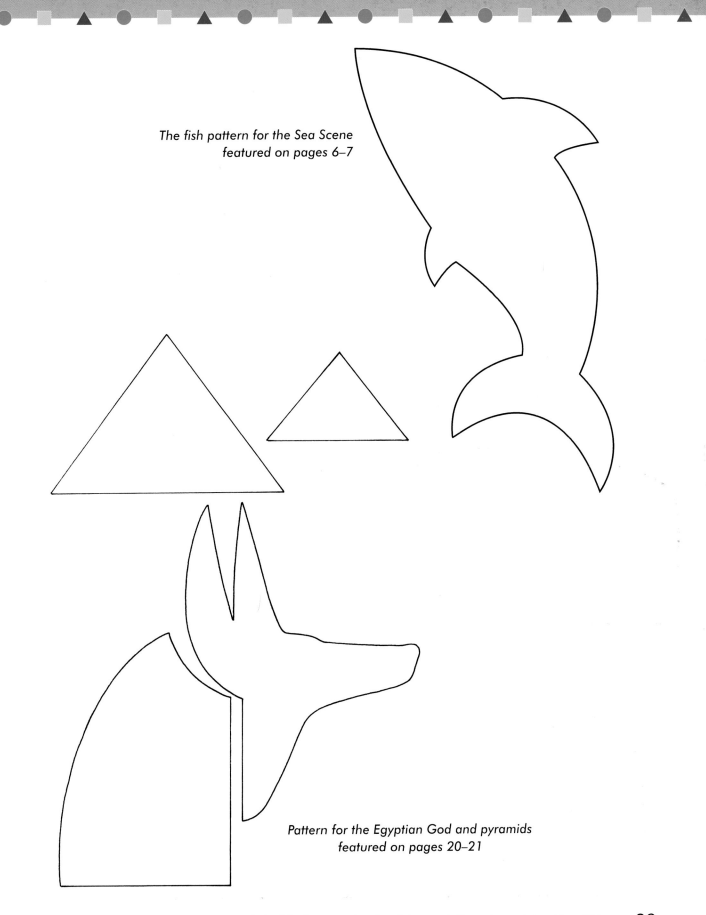

The fish pattern for the Sea Scene featured on pages 6–7

Pattern for the Egyptian God and pyramids featured on pages 20–21

Clay Modelling

by Greta Speechley

People have been modelling clay for thousands of years, and pottery fragments have been found that date back as far as 1200 BC. These early pots were baked in bonfires and, because the heat was not very intense, they were very fragile. As a result, only broken pieces of some of the vessels have survived to the present day. Some pots and models have been discovered in tombs and burial places, and you can see wonderful collections of these in many museums. Lots of these ancient vessels were highly decorated with painted figures and animals, which tell wonderful stories of how life used to be. The methods used by craftspeople in those far-off days were simple. Items were hand-modelled and moulded into useful and decorative shapes, just like they are today.

I have taken my inspiration from nature, the world around us, and the simple techniques used by our ancestors to show how easy it is to create colourful and fun models, zany pots, crazy containers and painted tiles. Each project shows a different way of using clay and suggests how you can paint your finished pieces with poster or acrylic paints. You might want to copy each one exactly to start off with, but I am sure that once you have done this, you will want to create your own unique pot or model.

It is a good idea to start using a sketch book or to keep a scrap book so that you can keep a note of the colours you like and use them on your models. Cut out bits of fabric, or snippets from magazines. Think about texture – do you want a smooth finish, or would you prefer a rough surface? Look at pottery and sculpture from different countries and decide which you prefer. My favourite pieces come from Mexico and South America. I love the little figures and curious animals that cover these pots, and they are always painted in such lovely vibrant colours.

I have used air-drying clay for all the projects in this section. It is easy to use and is available from most craft shops. There are quite a few different types. Try to find one that is squidgy when you poke it, rather than being hard. Clay is wonderful to work with – if it does not look quite right, you can just squash it up and start all over again, and it can be used to make almost anything. I am sure you will come up with lots of ideas of your own and have great fun clay modelling. The only limit is your imagination. Have fun!

Note If you have access to a kiln, you can use real clay for all the projects except the solid swinging tiger on pages 40–41. You must ask an adult to use the kiln for you.

Techniques

Clay is really easy to work with. You can model straight from a ball of clay, you can coil up long thin sausages, or you can make flat slabs which can be used to build boxes and containers. Practise these techniques before you start the projects.

Pinching out shapes

This very simple modelling technique is great for making small pots and bowls, and for modelling animals.

Hold a small ball of clay in one hand and press your thumb into the clay to make a hole.

Gently squeeze the clay between your thumb and fingers and work evenly round the ball of clay to open up the shape. Stop from time to time to see how your shape is progressing.

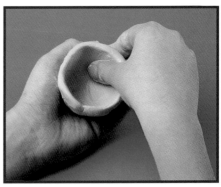

Note Before you start working on a project, always soften the clay by kneading it in your hands.

Rolling coils

You can use long clay sausages (coils) to build pots of any size and shape. The coils are made by rolling out the clay with your hands. For small pots, coils need to be about the thickness of your finger – make them a bit thicker for larger pots.

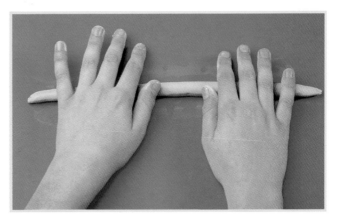

Making slabs

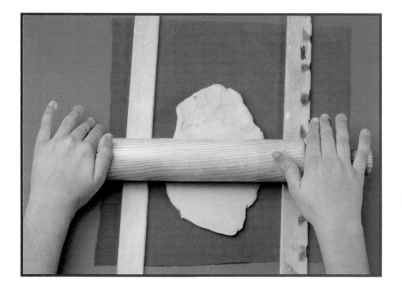

Flat slabs of clay can be used for tiles or for building boxes and containers. You will need a piece of cotton cloth (old cotton sheeting is ideal), a rolling pin and two lengths of wood. Place a ball of clay between the wooden lengths and flatten it with the rolling pin. The thickness of the wood controls the thickness of the slab.

Note It is much easier to roll out several small slabs than to try and roll out one huge one.

Cutting out shapes

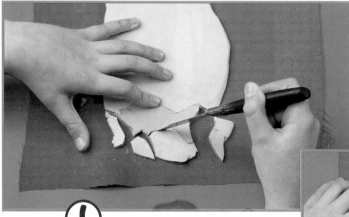

Use a paper pattern and a knife to cut out your design. Leave the clay to harden slightly before moving it, otherwise you may distort the shape.

You can use pastry cutters to make fun shapes which you can stick on to your pots.

Knives are sharp. Ask an adult to help you cut out the shapes.

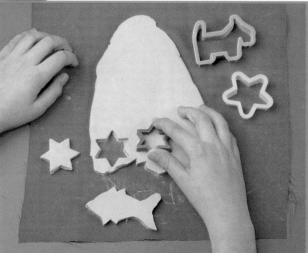

Creating patterns

Wonderful patterns can be made in slabs of soft clay by rolling the clay over textured cloth or leaves, for example. Designs can be scratched into the surface with a modelling tool, the end of a pencil or even a stick. You can also impress objects into the clay to make patterns.

Joining and attaching

When joining coils or attaching small pieces of clay to larger pieces, the clay surfaces should be scored then moistened with water before being pressed and smoothed together. Allow all slab pieces to harden slightly first, so that they can be handled without losing their shape.

Note Pieces of air drying clay can be glued together with strong adhesive if you decide you want to add something to your model or pot after it is dry.

 Use a modelling tool to score (roughen) all the edges to be joined.

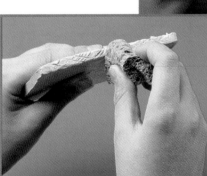

 Moisten the scored edges with a damp sponge.

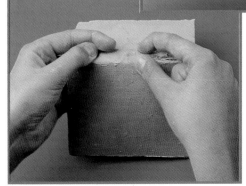

 Press the two edges together firmly, then use your fingers or a modelling tool to smooth the joins.

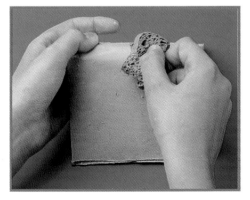

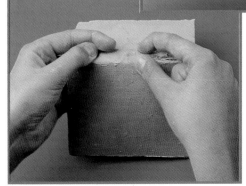 Finally, use a damp sponge on large pieces to create a really smooth finish.

Drying and painting

Before you paint your model, allow it to dry completely. The manufacturer's instructions will tell you how long you should wait, although it does depend on how warm your working environment is. If it is cold or damp, the drying time will be longer. Some instructions may tell you that you can speed up the process by drying the clay in the oven. This will harden the clay completely and make it more durable, but only do this if the instructions say so, and always get an adult to use the oven for you.

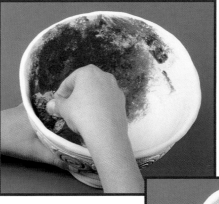

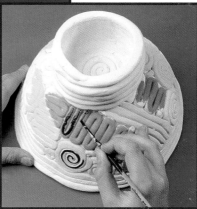

Note Acrylic paints dry very quickly and paintbrushes and sponges must be cleaned immediately after use or they will be ruined.

Acrylic paints are used for all the projects in this section. Poster paints can also be used, but you will need to seal them with acrylic varnish. The colours can be sponged on or you can use a brush to paint patterns and add fine details. An old toothbrush is ideal for spattering paint over surfaces. This creates lots of interesting effects, especially if you use several different colours.

Wobbly Pot

The pinching technique can be used to make a simple pinch pot like the one featured in this project. Throughout time, and in many different cultures, this style of pot has been used for various purposes. A good example is the diva pot used to hold small lights during the Hindu festival of Diwali.

YOU WILL NEED
Air-drying clay
Sponge
Modelling tool
Acrylic paints
Paintbrushes

1 Use the pinching technique (see page 32) to create a simple pot shape.

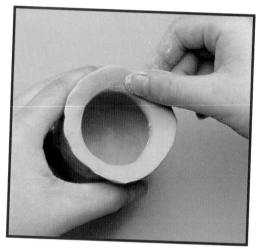

2 Squeeze the top of the pot to create a wavy edge. Leave it for half an hour to dry slightly.

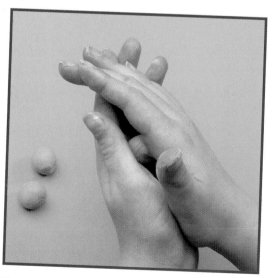

3 Roll three small balls of clay.

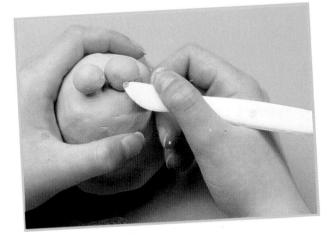

4 Score and moisten the surfaces to be joined (see page 34), then gently press each ball on to the base of the pot to form 'feet'. Smooth around the joins with a modelling tool. Leave to dry (see page 35).

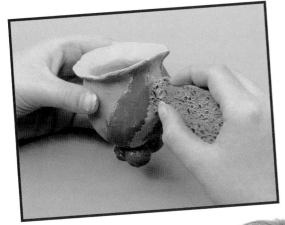

Use a sponge to add large wavy stripes of paint around the pot.

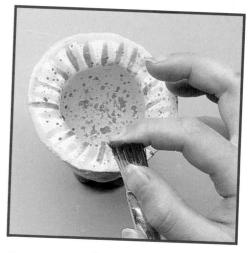

6 Dip a stiff paintbrush or old toothbrush into acrylic paint, then hold it over the pot and rim and pull back the bristles with your finger. This will create a spattered paint effect. Wash your hands immediately afterwards.

FURTHER IDEAS
You can make wide and narrow pots – egg cups too. Decorate them with spots, stars or diamonds.

Fat Cat

In this project, coils of clay are used to make the collar, flower and tail for the cat. The eyes and ears are pinched out of small amounts of clay. Animal sculptures by the artist Picasso could be used as inspiration. You can model lots of animals by just squeezing and stretching the basic pinch pot. The cat can be changed into a penguin or a mouse in an instant!

YOU WILL NEED
Air-drying clay
Sponge
Modelling tool
Acrylic paints
Paintbrushes

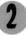 Make a basic pinch pot (see page 36). Turn it upside down and gently shape the head with your thumb.

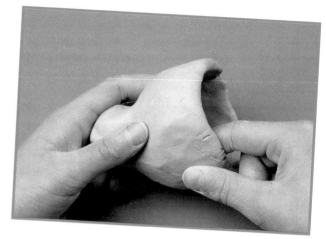

2 Squeeze the sides of the body, making it fatter than the head. Shape a nose and cheeks, then press in two eye sockets.

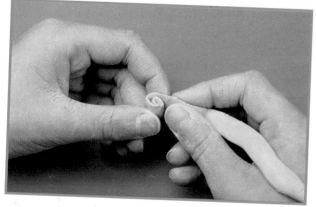

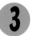 Roll out a coil of clay (see page 32) then flatten one end. Loosely spiral the flattened clay then pinch one end to form a flower head. Break off the flower then neaten the edge. Use the rest of the clay to make a collar and tail from coils, then two eyes and ears.

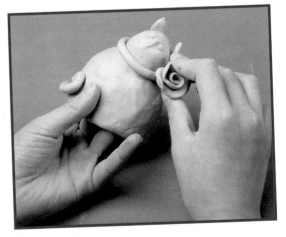

 Attach the eyes, ears, tail and collar to the cat then add the flower to the collar (see page 34).

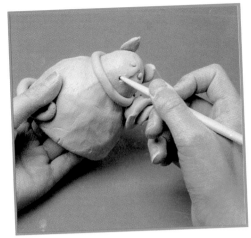

Use a pointed modelling tool to make a neat hole for the cat's mouth. Leave to dry.

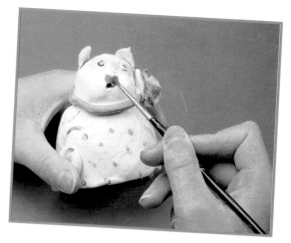

6 Sponge on a background colour and then use a paintbrush to add patterns to the body, the collar and the facial features.

FURTHER IDEAS

Try joining two simple pinch pots together and experiment to make other interesting animal models.

Swinging Tiger

Fun models like this tiger can be made from a solid lump of clay. Instead of pinching the clay into a pot shape, you simply roll it out and then pull out the arms and legs. Remember that the more clay you use, the longer it will take to dry. The smooth, pinched shapes of these models resemble the shapes of some African and Mexican sculpted creatures.

YOU WILL NEED
Air-drying clay
Modelling tool
Sponge • Acrylic paints
Paintbrushes
String or garden wire

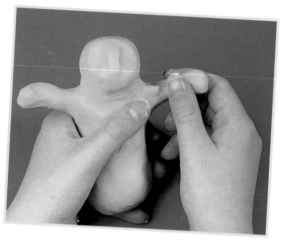

1 Roll out a fat clay sausage, shape a head and nose, then carefully pull two arms out from the sides of the body.

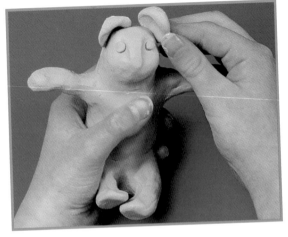

2 Model the bottom of the body and pull the legs out towards you. Add the eyes and ears.

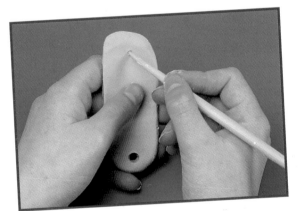

3 Model the swing seat from a slab of clay. Use the point of the modelling tool to make two small holes for the string or garden wire.

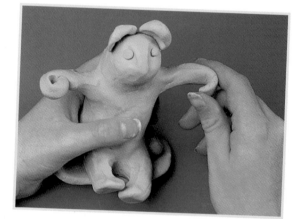

4 Attach the tiger to the seat. Bend the ends of its arms to form hands, leaving a hole in the middle of each for the string or garden wire to be pulled through. Leave to dry.

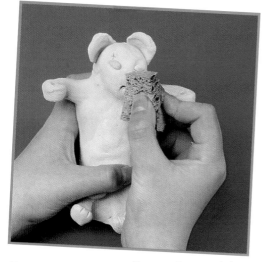

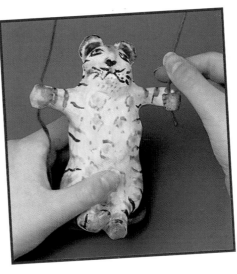

Thread the string or garden wire through the hands and seat, then knot the ends.

5 Sponge paint all over the model, then add stripes and facial features using a paintbrush.

FURTHER IDEAS

Try making your pet or even your best friend using this technique. You can add hair and facial features for people, then paint on colourful clothes.

Flower Pot

The technique of coiling is ideal for building up round symmetrical shapes like these flower pots. If you want your pot to be perfectly even, it is important to keep the coils the same thickness, and to continually turn the pot as you join and smooth the coils together. Look to artists and sculptors for ideas about what to paint on to or mould into the clay to decorate the flowerpot. Inspiration for the flowers could be taken from famous paintings such as Van Gogh's 'Sunflowers'.

YOU WILL NEED
Air-drying clay
Modelling tool • Pastry cutter
Garden or florist's wire
Pebbles • Moss
Acrylic paints
Paintbrushes

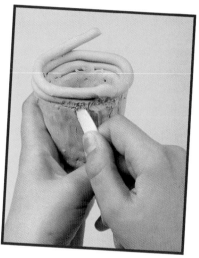

 2 Start to build up the walls of the pot using long, thin coils. Smooth the inside and outside surfaces with a modelling tool as you work upwards.

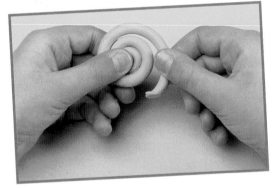

 1 Roll out a coil of clay and use it to make a base. Smooth the coil flat.

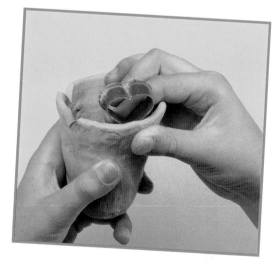

 3 When the pot is tall enough, smooth the top of the rim, then use part of a pastry cutter to create a fancy edge.

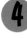 **4** Roll out a piece of clay and use the technique shown on page 38 to make small flower heads. Squeeze pieces of clay between your fingers and model them to form longer flower heads.

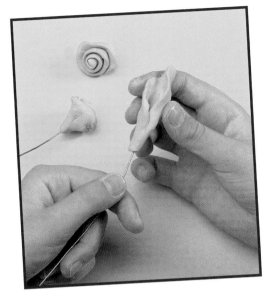

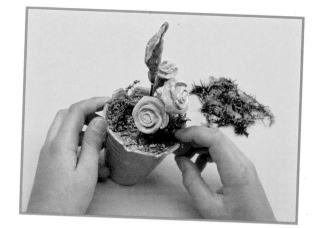

6 Paint the flowers and pot then leave to dry. Arrange the flowers in the pot and use small pebbles to hold the wire stems in position. Finally, cover the top of the pebbles with some moss.

 5 Push lengths of garden or florist's wire into each flower head then leave to dry.

FURTHER IDEAS

Air-drying clay is not waterproof, but you could build up the coils around a small glass jar, so you can then fill it with water and real flowers.

Squiggly Bowl

Coil pots used to be made by ancient cultures such as Native Americans. The coils provide an instant decoration which can then be painted in vivid colours. By using different thicknesses of coil and varying the shape of the coil you can experiment to produce different patterns and textures. In this project, a bowl lined with clingfilm acts as a mould, and coils are built up on the inside of the bowl. You can use any shape as a mould, provided that the top is wider than its base so that it is easy to remove the finished piece.

YOU WILL NEED
Air-drying clay
Mould (bowl)
Clingfilm • Sponge
Modelling tool
Acrylic paints
Paintbrushes

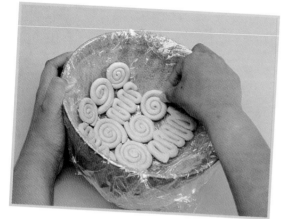

1 Line the inside of the mould with clingfilm, then lay squiggles and coils of clay inside the bowl.

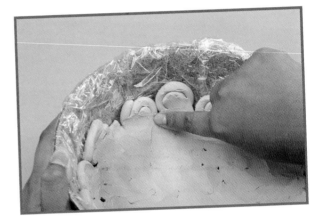

2 Join all the coils together by gently smoothing the inside surface with your fingers. Do not press too hard, as you want the coil pattern to remain on the outside.

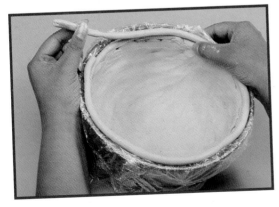

3 Lay two long coils of clay around the top of the bowl to form a rim. Allow the pot to harden slightly before removing it from the mould.

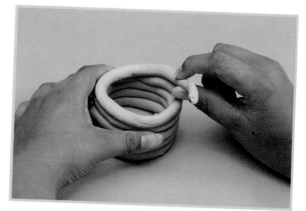

4 Make a base from long coils of clay. Smooth the inside of the coils together to make it stronger.

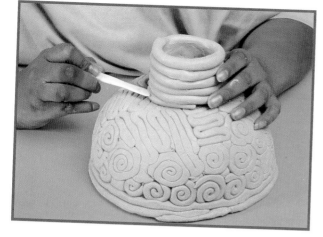

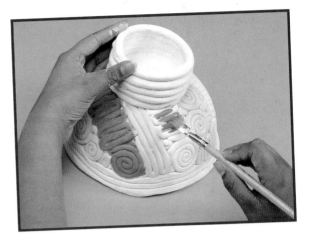

5 Turn the pot upside down and carefully attach the base (see page 34). Gently smooth the join with a modelling tool or your finger.

6 Allow the pot to dry completely, then paint the coils.

FURTHER IDEAS

Make two bowls then place one on top of the other to make a person's head like the one shown here. You could also make a model of the Earth using this technique.

Fish Tile

The simple tile in this project is created by rolling the clay into a slab and then decorating it with cut-out shapes and paint. Look for different examples of tiles for inspiration. You may find them in your own home, or in most religious buildings. You can also look at the work of the Spanish artist, Gaudi, to see all the amazing things that can be done with tiles.

YOU WILL NEED
Air-drying clay
Knife • Rolling pin
Two lengths of wood • Sponge
Modelling tool • Acrylic paints
Paintbrushes • Scissors
Piece of wood

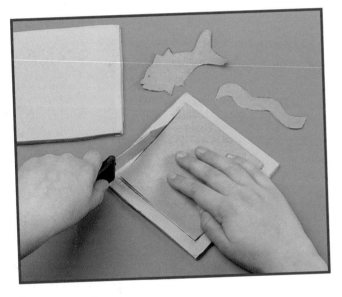

1

Photocopy the square, border, fish and wave patterns on page 55. Cut them out and then place them on a slab of clay. Use a knife to cut around the shapes then set them aside and allow to harden slightly. Roll a few tiny balls of clay to form bubbles.

Knives are sharp. Ask an adult to help you cut out the shapes.

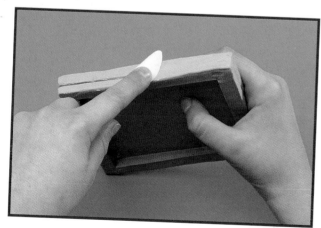

2 Attach the border to the square base (see page 34). Smooth the edges of the joins with a modelling tool.

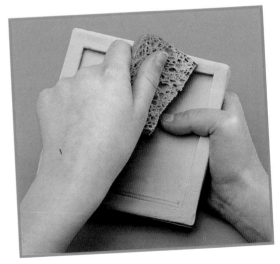

3 Use a sponge to smooth over the edges further, and to smooth over the front of the border.

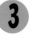

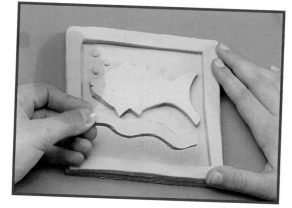

4 Attach all the pieces to the tile. Leave to harden slightly, then place a piece of wood on top to keep everything flat. Leave to dry thoroughly.

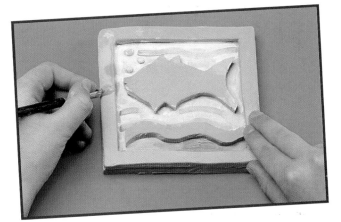

5 Paint the sea first, then apply a base colour to the fish, the wave and the border.

FURTHER IDEAS

You can use this technique to make a clock like the one shown here. Buy the clock mechanism first so that you know how big to make the hole in the clock face.

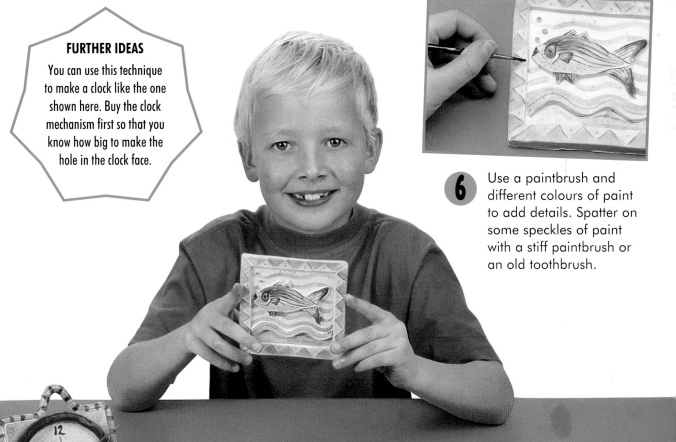

6 Use a paintbrush and different colours of paint to add details. Spatter on some speckles of paint with a stiff paintbrush or an old toothbrush.

Treasure Box

The decorations for this box are attached by scoring and moistening the two pieces of clay then joining them together. You could also explore other methods of decoration such as carving in shapes using modelling tools.

YOU WILL NEED

Air-drying clay
Knife • Rolling pin
Two lengths of wood
Modelling tool • Sponge
Acrylic paints
Paintbrushes

Photocopy the square patterns for the Treasure Box on page 55, then cut them out from slabs of clay. Allow the slabs to harden slightly then use a modelling tool to score the surfaces that will be joined.

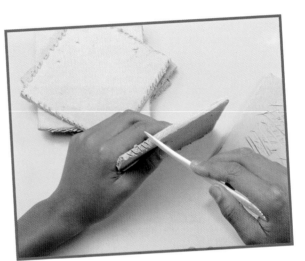

(!) Knives are sharp. Ask an adult to help you cut out the shapes.

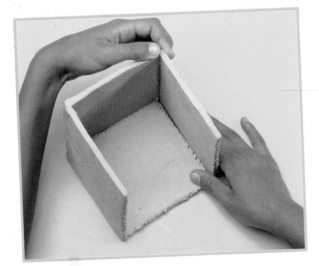

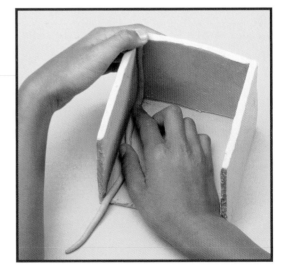

2 Moisten the edges with a sponge then assemble the box as shown, with the scored edges touching one another. Leave off one side for the moment. Pinch and squash the clay pieces together then smooth over the outer joins.

3 Roll out long thin coils, then press and smooth these over the inside joins to strengthen them. Attach the remaining side then carefully strengthen that with a coil.

 4

Join the two lid slabs together, then attach a long coil of clay around the outer edge. Smooth over the join. Turn the lid over.

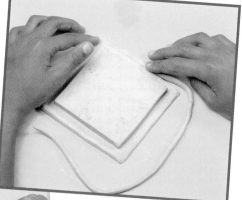

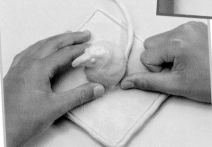

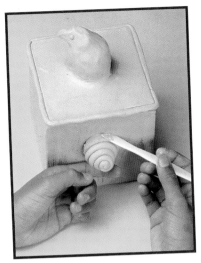

 6

Decorate the sides with coiled shapes, smoothing over the joins with a modelling tool. Let the box dry before painting it.

 5

Model a small animal (see pages 38–39) and attach it to the top of the lid with a thin coil. Smooth over the join.

FURTHER IDEAS

You can convert this treasure box into a money box by cutting a slot in the lid before the clay dries.

Pencil Holder

Clay is an important material in the production of practical items, as well as being useful for producing decorative ornaments. The techniques used in this project are the same as those for the Treasure Box on pages 48–49, but the joins are strengthened on the outside rather than the inside.

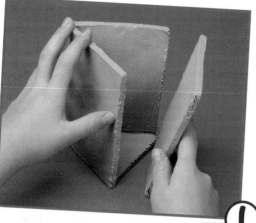

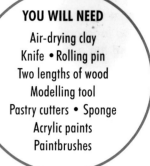

1 Photocopy the patterns on page 55, then cut them out from slabs of clay. Allow the slabs to harden slightly, then assemble the triangle and three rectangles to form the basic pot shape.

Knives are sharp. Ask an adult to help you cut out the shapes.

2 Roll out three long coils of clay, then smooth them on to the outside edges to strengthen the holder.

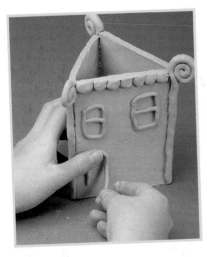

3 Decorate one side of the pencil holder using thin coils of clay to create windows, roof tiles, a door and even a milk bottle on the doorstep.

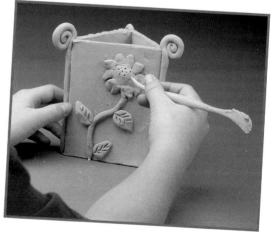

4 Use a coil and small pieces of clay to add a sunflower on one of the other sides. Use a pointed modelling tool to add veins to the leaves and seeds to the flower head.

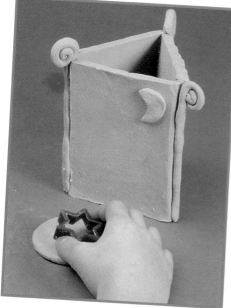

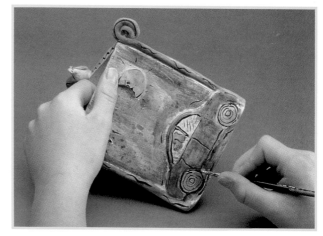

 Use pastry cutters to cut out a moon and stars to decorate the third side.

6 Attach the car to the pot to complete the scene. Leave to dry, then paint the pot with bright colours.

FURTHER IDEAS
Make your own house, or create a whole village! Alternatively, make a big pot and use it to hold cooking utensils.

Lion Dish

Your imagination can really run wild with this dish. I show you how to make a lion, but all kinds of shapes can be produced to make a variety of fantastic creatures. Use a mixture of decorative techniques to finish it off, including moulding, attaching clay shapes or creating patterns using clay tools.

YOU WILL NEED
Air-drying clay
Rolling pin • Two lengths of wood
Mould (dish) • Clingfilm
Sponge • Modelling tool
Garlic press or sieve
Acrylic paints
Paintbrushes

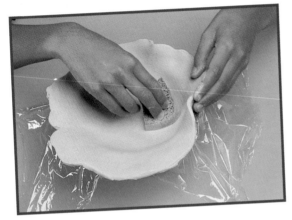

 Cover the mould with clingfilm. Roll out the clay, then lay it over the mould. Gently ease the clay down using a sponge.

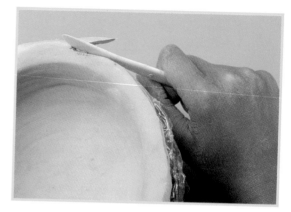

2 Trim off excess clay with a modelling tool. Allow the clay dish to harden slightly, then remove it from the mould.

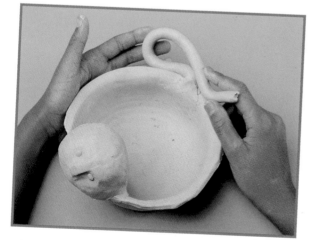

 Squeeze a ball of clay through a garlic press or sieve to create the lion's mane and tail.

3 Model a head and tail then attach them to the rim of the dish. Shape two ears and attach them to the head. Smooth over the joins with your fingers.

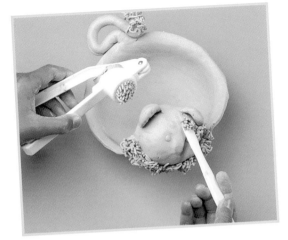

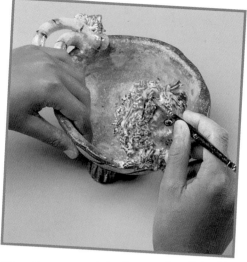

5 Use a modelling tool to transfer the squeezed clay on to the end of the lion's tail and mane. Press the strands down well, then leave the dish to dry.

6 Sponge paint all over the dish. Use a paintbrush to add decoration and to colour in any areas that are hard to reach with a sponge.

FURTHER IDEAS

Use jelly moulds to create interesting shapes! Look at animal books for interesting colours and patterns.

Patterns

The patterns on these two pages are the size that I used them for the projects, but you can make them larger or smaller on a photocopier if you wish. Once you have photocopied the patterns, you can cut them out and then place them over your clay and cut around the outline with a knife.

!

Get an adult to help you photocopy the patterns.

You will also need an adult to help you cut out the clay shapes.

Patterns for the Pencil Holder featured on pages 50–51. You will need three rectangular slabs of clay, one triangular slab and one car shape.

Patterns for the Fish Tile featured on pages 46–47. You will need two large square slabs of clay. Use one whole square for the background of the tile. Make the border from the other by cutting out the small square. Cut the fish and wave shapes from the remaining clay.

Patterns for the Treasure Box featured on pages 48–49. You will need five large square slabs for the actual box, and one large and one small square slab for the lid.

Beadwork

by Michelle Powell

Beads have been used for thousands of years in many different countries around the world. The earliest beads were found in the tombs of ancient Egyptians, and were made from semi-precious stones, shells, bone and gold. Beads were used not only as personal decoration but also as money. It became popular for people to carry their money beads on a string around their neck, to keep the beads safe, and to show how wealthy and important they were.

Certain types of beads also showed a person's religious or superstitious beliefs. The word bead comes from the Anglo-Saxon 'bede', meaning 'prayer'. People of many religions carry strings of rosary beads, each bead representing a prayer or psalm. Some people carry a talisman – a carved stone or other small object – believing that it will ward off evil spirits. Others wear a lucky charm, hoping that it will bring them good fortune.

Later, metal coins were used as currency. Some countries still have holes in their coins so that they can be strung together and worn as a necklace. Beads are now more normally used to make attractive jewellery and in craft projects like the ones in this section.

There are many different types of beads available. Some are made from beautiful gemstones dug from the ground such as garnet, turquoise and quartz. Amber beads are made from tree resins that have hardened in the ground for thousands of years. Precious metals such as gold and silver are also made into beads. Pearls are made in an oyster shell. This happens when a tiny grain of sand gets in to the shell. The oyster surrounds it with a special substance to make it smooth.

Many beads are made from glass. They are blown into shape or cut by highly skilled craftspeople. Wood and clay are also popular materials used to make beads. Plastic beads are made in lots of shapes and colours, using moulds.

This section shows you how to make many projects using beads and beading techniques. There are patterns at the end of the section to help you, and page 78 shows you how to transfer them on to your projects. You can make some of the beads yourself from air-drying clay, felt or high-density foam. Other projects use shop-bought beads such as tiny seed beads, larger plastic pony beads and even large polystyrene balls.

Bonsai Tree

In Japan, the art of growing tiny trees in shallow pots is called Bonsai. You can make your own miniature Bonsai trees, using sequins shaped like leaves and flower beads fastened on to wire branches. Fix the trees in some oasis and put them in small pots on your windowsill. You could make this spring tree covered in pink blossom, or use leaf beads or sequins in oranges, browns and reds for an autumnal tree.

YOU WILL NEED
30 pieces of wire, 23cm (9in) long
Some extra wire
Flower beads • Leaf sequins
Oasis • Brown flower tape
Small plant pot • Chopping board
Old scissors • Knife • Ruler
Fine gravel • PVA glue

1 Using old scissors, cut thirty pieces of wire, 23cm (9in) long. Twist them together to half way along their length. Wrap brown flower tape around the twist. This makes the trunk of the tree.

(!) Ask an adult to help you to cut the wire.

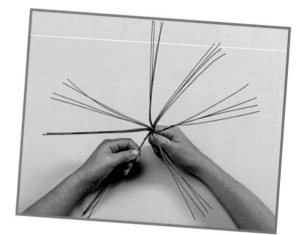

2 Split the bunch of wires into seven groups. Each group will make a branch of the tree. Twist the wires in each branch together to about half way along the branch.

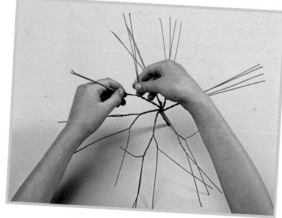

3 Divide each branch into two smaller branches. Twist the wires of the smaller branches together for a few centimetres. Leave wires sticking out in a 'v' shape at the end of each branch like twigs.

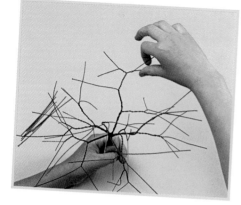

 4

Ask an adult to help you to cut fourteen 5cm (2in) lengths of wire, using old scissors. Add them to the 'v' shapes at the ends of your branches. Twist them together with each side of the 'v', to thicken your twigs.

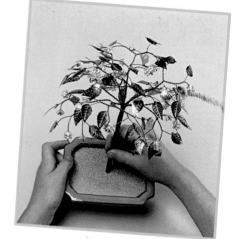

5

Take a flower bead and push a wire 'twig' through the hole. Push the bead 1cm (½in) down the twig. Bend back the end of the wire towards the centre of the flower. Now push a leaf sequin 1cm (½in) down another twig. Bend the wire over the top of the leaf and tuck it in round the back. Decorate the whole tree with flowers and leaves.

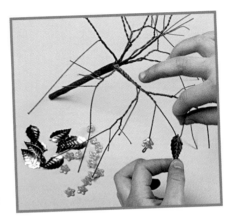

6

Using a knife and a chopping board, carefully cut oasis to fit your pot and push it in. Push in your bonsai tree. Cover the top of the oasis with PVA glue, and sprinkle on gravel.

(!)

Ask an adult to help you to cut the oasis.

FURTHER IDEAS

Make a bonsai garden, or make a partridge from card and put it in a pear tree for Christmas.

Indian Wall Hanging

Traditional Indian clothes are made from bright fabrics in beautiful colours, often with shimmering metallic threads. This wall hanging is like an Indian decoration with its bright colours and shiny sequins. The stuffed felt beads are in the shape of birds, which often appear in Indian art and crafts. The small beads are rolled from strips of felt and decorated with felt in contrasting colours. Straws are used to make good holes through the beads so that they are easier to string together.

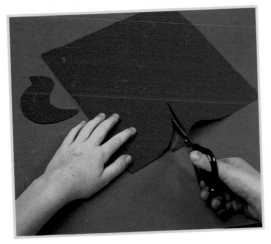

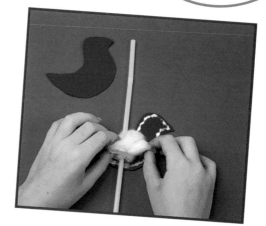

1 Transfer the bird design on page 79 on to card. Cut out the shapes and draw round them on felt, using a felt pen. Cut out two body shapes (front and back) and two wings for each bird. The wings should be in a contrasting colour.

2 Put a line of fabric glue around the edge of one back body piece. Lay a straw on the felt, and put cotton wool on top.

3 Push a front body piece on to the glue so the two halves of the bird stick together. Repeat steps 1–3 for four more birds.

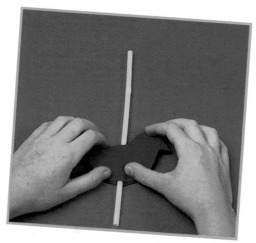

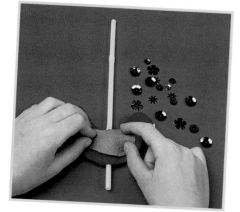

4

Glue different coloured wings on to each bird. Glue on small triangles of yellow felt for beaks. Glue on sequins for decoration. Cut off the excess straw close to the felt.

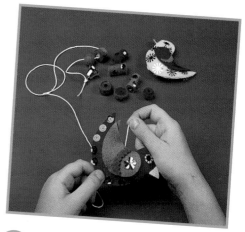

5

Cut thirteen strips of felt, 8cm (3¼in) long and 1cm (½in) wide. Cover one side with fabric glue and roll them around a straw to make felt beads. Leave to dry and then cut off the excess straw close to the felt.

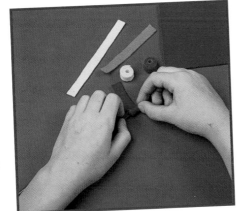

6

Use pinking scissors to cut strips of felt 5cm (2in) long and 5mm (¼in) wide. Glue them around your felt beads for decoration. Tie a bell on to a 60cm (23½in) piece of string. Push the string through the straws inside two felt beads. Next, thread a bird on to the string in the same way, then two more felt beads. Carry on until all the birds are on the string, then add three beads at the top.

FURTHER IDEAS
Design your own Indian style wall hanging using an elephant shape instead of a bird.

Egyptian Picture Frame

King Tutankhamen was a famous Egyptian pharaoh. After he died, a beautiful mask was made of his face and buried with him in his pyramid tomb. More than three thousand years later, archaeologists discovered this mask and many other buried treasures, which were signs of his wealth and importance as a leader. This picture frame uses small seed beads and long, straight bugle beads glued on to a wooden frame in a mosaic style, to create the look of King Tutankhamen's beautiful mask.

YOU WILL NEED
Wooden picture frame
Seed and bugle beads
Acrylic poster paint
Paint brush
PVA glue • Cocktail stick
Carbon paper • Tracing paper
Masking tape • Pencil

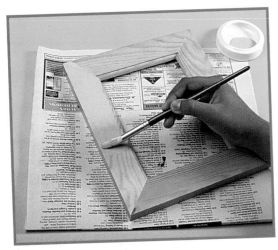

1 Paint the picture frame a pale colour, using acrylic poster paint. Leave it to dry.

2 Transfer the design on page 79 on to the frame.

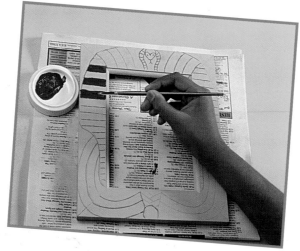

3 Paint stripes of colour on to the frame as shown. Continue painting the design, leaving blank areas for beads between the colour.

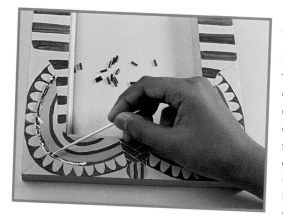

Paint other areas of the design as shown and leave to dry. Put a line of glue on the design. Use a cocktail stick with a blob of glue on the end to pick up the long coloured bugle beads. Position the beads along the glued line.

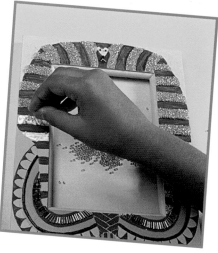

Squeeze a thin layer of glue on to the unpainted semicircles at the bottom of the frame. Arrange the long gold beads, using the cocktail stick as before. Add glue to the unpainted striped areas and sprinkle on gold seed beads.

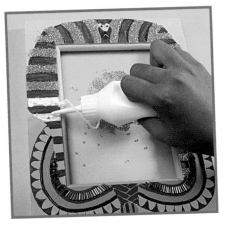

Press down the gold seed beads. Sprinkle on more to fill any gaps and leave the frame to dry.

FURTHER IDEAS
Design your own frame, and put in a picture inspired by the ancient Egyptians.

Fish Pen Toppers

Decorate your pens and pencils by making beaded fish and octopus toppers. The fish are made from a polystyrene ball, and sequins are used to look like the fish's scales. Small plastic faceted beads are used to make the fins and tail. Faceted beads are cut to have many flat faces or facets, like diamonds. This will give a shimmery feel to your fish. You could find some pictures of fish to copy or just use your imagination to create colourful fishy friends.

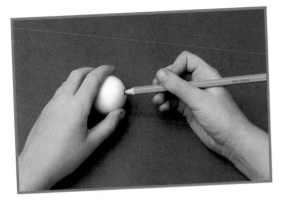

YOU WILL NEED

Pencil to decorate
Sequins • Beads
Thin wire • PVA glue
4cm (1½in) polystyrene balls
Scissors • Old scissors
Darning needle
Ruler

1 Use the pencil to make a hole in the polystyrene ball.

2 Glue the ball to the top of the pencil using PVA glue. Leave to dry.

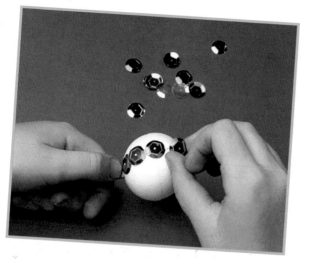

3 Glue on a stripe of coloured sequins from the pencil hole, up and over the polystyrene ball and back to the pencil hole. Cover half of the ball with coloured sequins in the same way, and the other half with clear sequins. These will make the fish's face. Leave to dry.

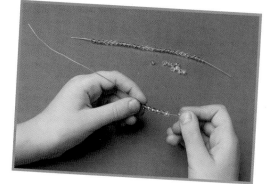

4

Using old scissors, cut two 18cm (7in) lengths of wire. Thread twenty-five beads on one for the tail and twenty-five on the other for the fin. Bend the beaded wires into tail and fin shapes like those shown in the pattern on page 81.

(!) Ask an adult to help you to cut the wire.

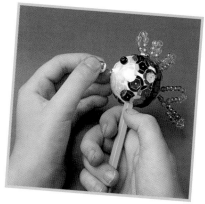

5

Make two holes in the ball with the darning needle where you want to add the fin. Put a blob of glue on each hole. Take the beaded fin and push one end of it into each hole. Do the same for the tail.

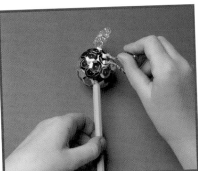

(!) Ask an adult to help you to use the darning needle.

6

Place a blob of glue on either side of the face for the eyes and in the centre for the mouth. Push a black bead on to the glue for the eyes, and a clear bead for the mouth.

FURTHER IDEAS

Make beaded fish without the hole for a pencil. Attach magnets to the side to make fridge magnets.

African Beaded Curtain

The shapes and colours of this beaded curtain are taken from designs used to decorate African pottery. The leaves and curling vines look like the hanging canopy found in African forests. The beads are made from foam shapes and coloured drinking straws. Hang the curtain in the doorway of your bedroom, to give it an African theme.

YOU WILL NEED
High-density foam
Scissors • Large needle (bodkin)
Acrylic poster paint • Paint brush
Drinking straws • String
Pencil • Masking tape • Card
Tracing paper • Carbon paper
Wooden dowel the width of
your door

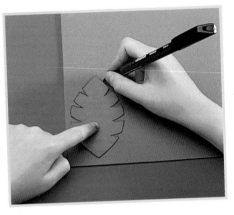

2 Cut out eleven of each shape from the different coloured foam. Cut out eleven foam strips 30 x 2cm (11¾ x ¾in).

1 Transfer the patterns from page 80 on to card. Cut out leaf, triangle, star, zigzag and diamond templates. Draw round the templates on coloured foam.

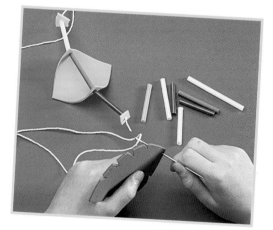

3 Paint the straws and cut them into various different lengths.

4 Cut the string into seven 2m (6½ft) lengths and thread one length on to the bodkin. Thread one end of a shape on to a string. Thread on a short piece of coloured straw, then thread on the other end of the shape. Thread a piece of straw in between each shape. Continue threading the shapes in this way.

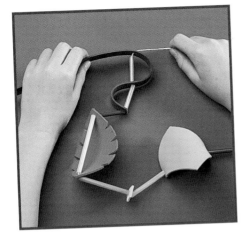

 5 To thread the strips, make a small mark on the strip every 6cm (2¼in). Starting at one end, thread the needle and string through the strip, then through a short piece of straw, then again through the strip. Repeat to the end of the strip.

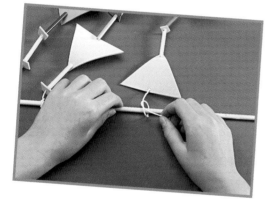

 6 Thread shapes and straws on to all the strings. Tie the end of each string on to the dowel. The curtain is now ready to put up in your doorway.

(!) Ask an adult to cut the dowel to the right length, and to hang the finished curtain for you.

FURTHER IDEAS

Decorate a foam band and put it round your head to make an African headdress.

Native American Shaker

Native Americans often made clothes and bags with a beaded tassel trim. Animal hide was cut into strips and threaded with beads for decoration. This shaker is made in a similar way, using felt cut into tassels, with pony beads threaded on to make a design. The felt is wrapped around a pot filled with more beads so that you can make music.

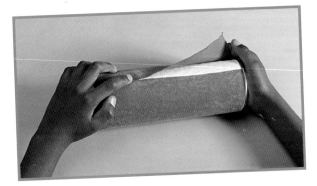

1 Cut a piece of fabric large enough to fit round the crisps pot. Cover the pot with PVA glue and leave until it is tacky. Glue the fabric on.

2 Cut two strips of felt, one 7cm (2¾in) wide and the second 18cm (7in) wide. Both must be long enough to go round the crisps pot. Draw lines 1cm (½in) apart on the strips. Cut fringes as shown, using the lines as a guide and cutting to 2cm (¾in) from the top.

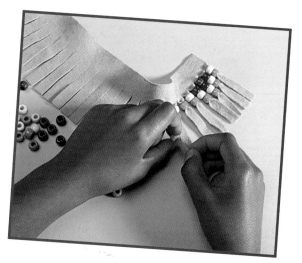

3 Thread beads on to the fringe of the smaller strip as shown, to make a pattern. Decorate the other fringe in the same way.

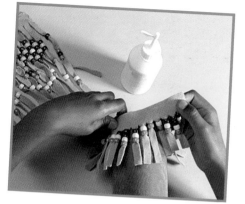

4 Glue the long fringe around the pot so that the tassels hang to the bottom of the pot. Glue the short fringe around the pot near the top.

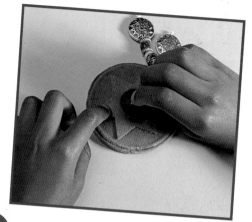

5 Put any leftover beads into the pot to make the shaker noise.

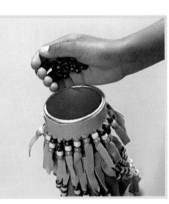

6 Draw round the lid and cut out a circle of felt. Glue it on to the lid. Add a turquoise trim. Transfer the star and circle patterns on page 79 on to felt and cut them out. Stick the star on to the lid. Thread some decorative beads on to two 10cm (4in) pieces of string. Snip a tiny hole in the middle of the circle. Push the ends of the strings through the hole and glue the circle on top of the star.

FURTHER IDEAS
Make a fringed drum from a plastic tub to go with your shaker.

Gecko Key Ring

Geckos are lizards that live in warm countries. Their feet stick to smooth surfaces, so that they can run up walls and even across ceilings! These cute gecko key rings are great fun to make. Coloured pony beads are threaded on to string to form the shape of the gecko. You could use any beads, but make sure that the string you are using will pass easily through the bead hole twice. This technique is ideal for making reptiles like snakes, frogs or turtles, because the beads look like the patterns on scaly skin.

YOU WILL NEED
Eighty-five pony beads
Split ring
String
Scissors

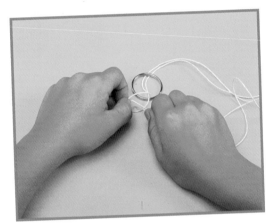

1 Cut 1m (39½in) of string. Fold it in half and loop it through the split ring. Push the two ends of the string through the loop and pull tight.

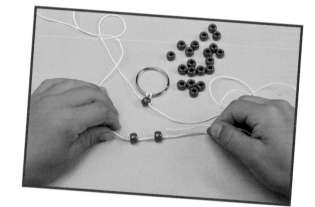

2 Look at the pattern on page 81. Thread one bead on to one of the strings, then push the other string through the bead in the opposite direction. Push the bead right up to the ring. Next thread two beads on to one string and thread the other string through in the opposite direction. Push both beads tight against the first bead.

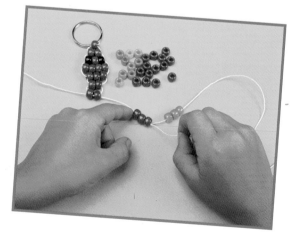

3 Continue following the pattern to make the gecko's head. Push the beads tight against each other after threading each row. To make the first leg, thread three dark and three light coloured beads on to one string. Bring the string round and thread it back through the dark beads.

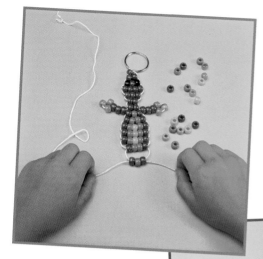

Make the second leg on the string on the other side. Now continue with the body, following the pattern. Pull the strings tight after threading on each row of beads.

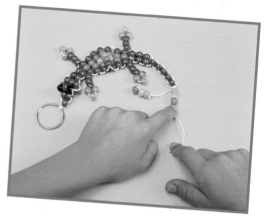

5 Make the gecko's back legs in the same way as the front legs. Next thread two beads on to the string on one side, and then thread the other string through the beads in the opposite direction. Continue following the pattern in the same way to make the tail.

6 Tie off the strings together at the end of the tail. Now thread three more beads on to each remaining length of string, for decoration. Knot and cut off both strings.

FURTHER IDEAS

Make zip pulls or a mobile with your beaded creatures, or use glow in the dark beads to make aliens or ghosts!

Rainbow Sun Catcher

This sun catcher's pattern is in the shape of a traditional stained-glass window. The stained-glass windows in churches show scenes from the Bible. In times when many people could not read, preachers used them to teach people about Bible stories. For this sun catcher, you need pony beads that are coloured but transparent, so that the light will shine through them, as well as some opaque beads. The beads are threaded on to strings, so that when they are hung together, they will form a picture of the sun rising, a rainbow and a moonlit sky, all in a window frame. Stick your sun catcher to your window, and wait for some sunshine to bring it to life!

YOU WILL NEED
Black and metallic opaque pony beads
Clear, coloured pony beads
A kebab stick
Three window suckers
Ruler • Scissors
String

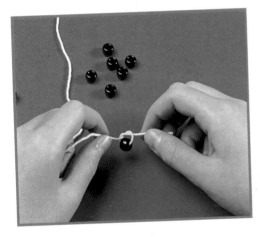

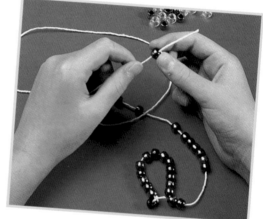

1 Cut twenty-four lengths of string, 50cm (20in) long. Tie a black pony bead to one end of twenty-three of them. Tie an opaque metallic bead to the end of the other one. Pull the knots tight.

2 Look at the pattern on page 81. Using the first string, thread the opaque metallic beads and the clear beads in column one. Thread the last clear bead on to the string.

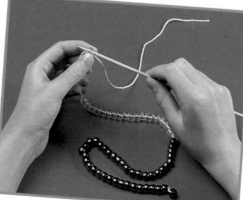

3 Now thread this last clear bead on to the kebab stick. Tie the string round the kebab stick and cut off the end of the string.

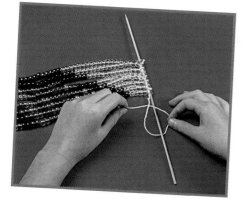

Carry on threading beads on to the strings, one column at a time, following the pattern. Push the kebab stick through each final bead and tie the string round the kebab stick as shown.

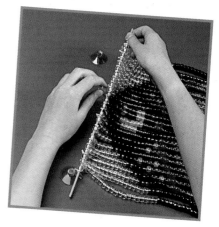

Continue following the pattern, tying off the ends and cutting off the excess string.

Hook three window suckers on to the kebab stick. Now the sun catcher is ready to be attached to your window.

FURTHER IDEAS
Add bells to the bottom of the sun catcher and hang it up to make a wind chime.

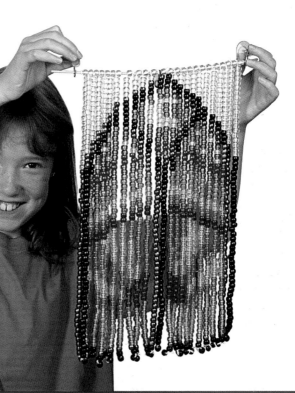

Astronaut Puppet

Polystyrene balls can be used as huge beads and strung together to make an astronaut puppet wearing a space suit. You will need polystyrene balls in the following shapes and sizes: two 8cm (3¼in) egg shapes for the hands; two 10cm (4in) egg shapes for the feet; one 9cm (3½in) ball for the head; one 11cm (4¼in) ball for the body; two 6cm (2¼in) balls for the shoulders; four 8cm (3¼in) balls for the legs, and four 7cm (2¾in) balls for the arms and legs.

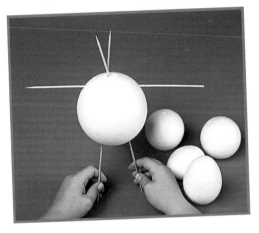

1 Use a kebab stick to push a hole straight through the middle of all the polystyrene balls except the body. Make three holes in the body as shown, and then pull out the kebab sticks.

Ask an adult to help you to make holes with the kebab sticks.

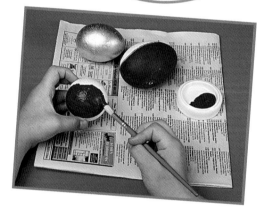

2 Paint two of the egg shapes as gloves, and the other two as space boots. Paint the details of the face and helmet and the body. Paint the polystyrene block. This will be the astronaut's oxygen tank.

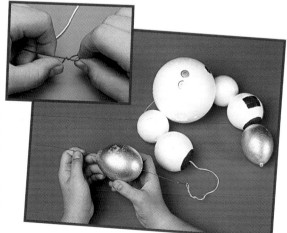

3 Make a long needle by twisting the end of a piece of wire as shown. Thread it with elastic thread. Tie a knot, then thread on a small bead, a glove, two arm beads, the body and then another two arm beads, the other glove and a second small bead. Then tie another knot.

Thread another piece of elastic thread through a small bead, a boot and three leg beads. Push the needle up through one of the body holes, then down through the second hole. Thread on three more leg beads, a boot and a bead, and tie a knot.

4

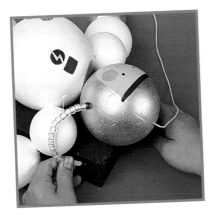

5 Thread a piece of elastic thread down through the head bead and tie it to the loop left by the legs. Stick the oxygen tank to the body using PVA glue. Thread some clear beads on to a pipe cleaner, and push one end in the helmet and the other end in the oxygen tank.

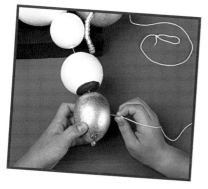

6 Make small wire hooks and stick them in the knees and hands, then tie on four lengths of string 75cm (29½in) long. Tie the other ends to the two pieces of wooden dowel, tied in a cross shape. Put another wire hook in the head, and use string to attach it to the centre of the dowel cross.

FURTHER IDEAS
Thread painted polystyrene balls on to string and hang them up to make a planet mobile.

Aztec Game

The Aztecs lived in Mexico around five hundred years ago. They were warlike people but they also made amazing art and crafts. They carved the shapes of faces and animals in to tall wooden poles, to make sculptures. This game is based on Aztec sculptures. The playing pieces are large clay beads in the shapes of birds and faces. You need fourteen birds and fourteen faces to play three-dimensional noughts and crosses.

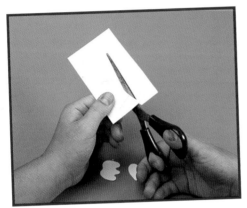

1 Transfer the tail, feet and wing patterns on page 80 on to card and cut them out to make templates.

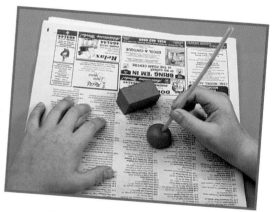

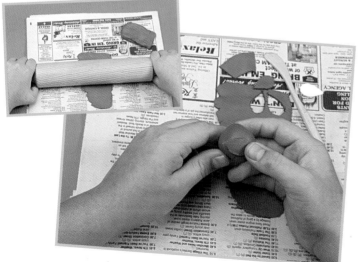

2 Roll twenty-eight balls of clay the size of a walnut in your hands. Use the straw to make a hole through the middle of each ball.

3

Roll out a piece of clay about 4mm (¹/₈ in) thick and use the templates to cut out wing, feet and tail shapes for the birds. Stick these to fourteen of the clay beads.

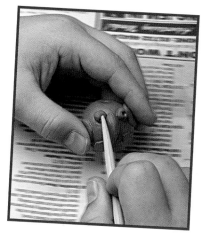

Roll balls for the eyes. Press them on to the clay beads, using a little water to help them stick. Use a clay cutting tool to indent the eyeballs and make grooves in the wings and tails. Leave to dry.

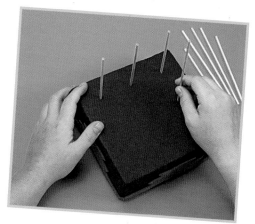

Paint the fourteen bird beads and leave them to dry. Now make fourteen Aztec face beads using the face pattern on page 80. Paint them, too.

Take the square of polystyrene and cover it with felt. Use the pattern on page 80 to make a felt decoration for each side. Push the pieces of dowel into the square in evenly spaced rows of three. Now you can play three-dimensional noughts and crosses with the birds and face beads – any straight line of three beads wins!

FURTHER IDEAS
Make a draughts board from card and use your beads to play draughts.

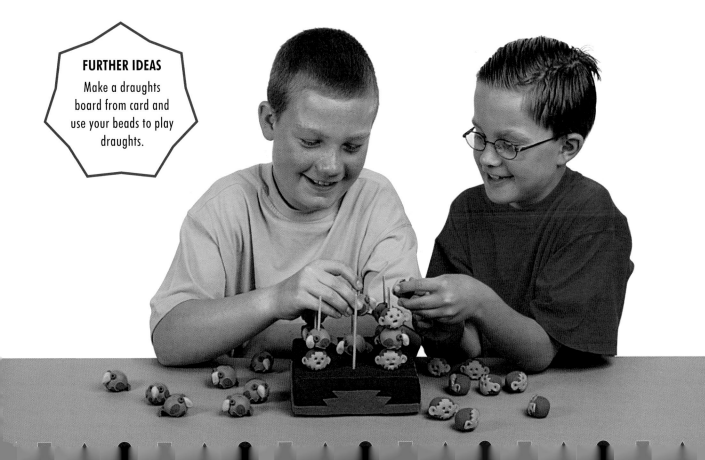

Transferring Patterns

You can trace the patterns on these pages straight from the book (step 1). Alternatively, you can make them larger or smaller on a photocopier if you wish, and then follow steps 2–4 to transfer them on to your project.

Get an adult to help you enlarge the patterns on a photocopier.

1 Place a piece of tracing paper over the pattern, then tape it down with small pieces of masking tape. Trace around the outlines using a soft pencil.

2 Place the tracing paper or photocopy on the surface of the project and tape it at the top. Slide the carbon paper underneath and tape it at the bottom.

3 Trace over the outlines with the pencil, pressing down firmly.

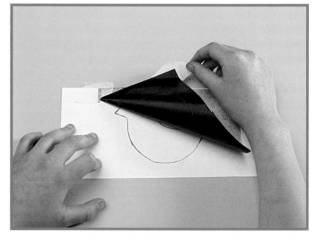

4 Remove the tracing paper, and the carbon paper, to reveal the design.

Patterns

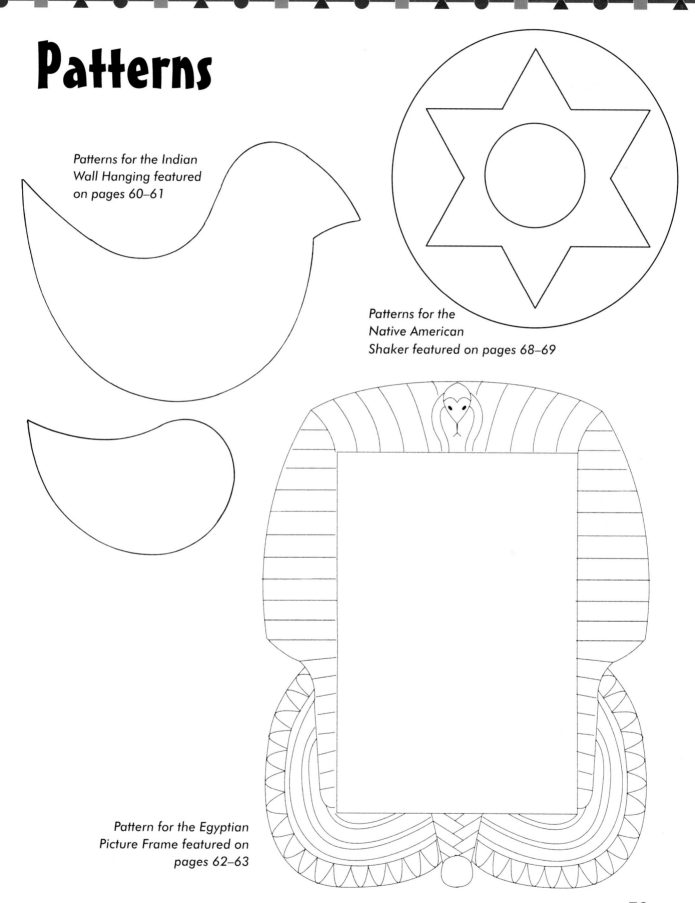

Patterns for the Indian Wall Hanging featured on pages 60–61

Patterns for the Native American Shaker featured on pages 68–69

Pattern for the Egyptian Picture Frame featured on pages 62–63

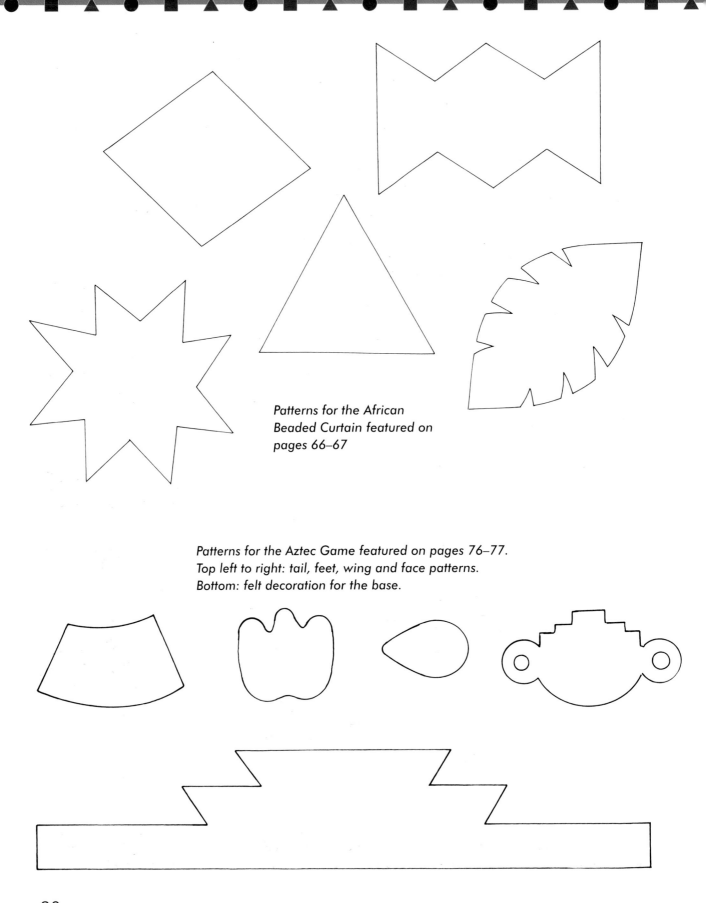

Patterns for the African Beaded Curtain featured on pages 66–67

Patterns for the Aztec Game featured on pages 76–77.
Top left to right: tail, feet, wing and face patterns.
Bottom: felt decoration for the base.

Pattern for the Rainbow Sun Catcher featured on pages 72–73

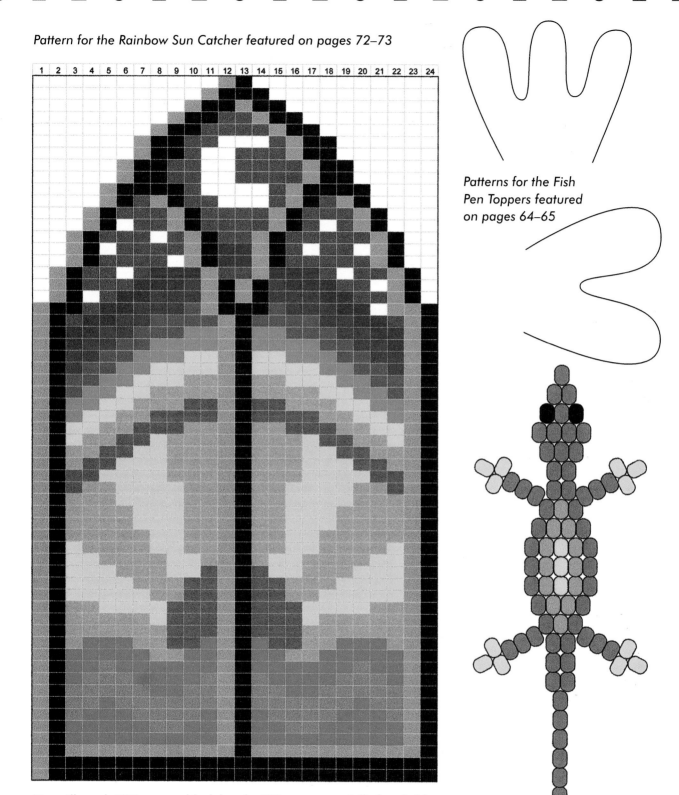

You will need: 237 opaque black beads; 190 opaque metallic beads (shown as grey); 128 clear turquoise beads; 68 clear red beads; 90 clear green beads; 194 clear orange beads; 140 clear yellow beads; 32 clear purple beads; 34 clear pink beads; 95 clear blue beads and 208 clear colourless beads.

Patterns for the Fish Pen Toppers featured on pages 64–65

Pattern for the Gecko Key Ring featured on pages 70–71

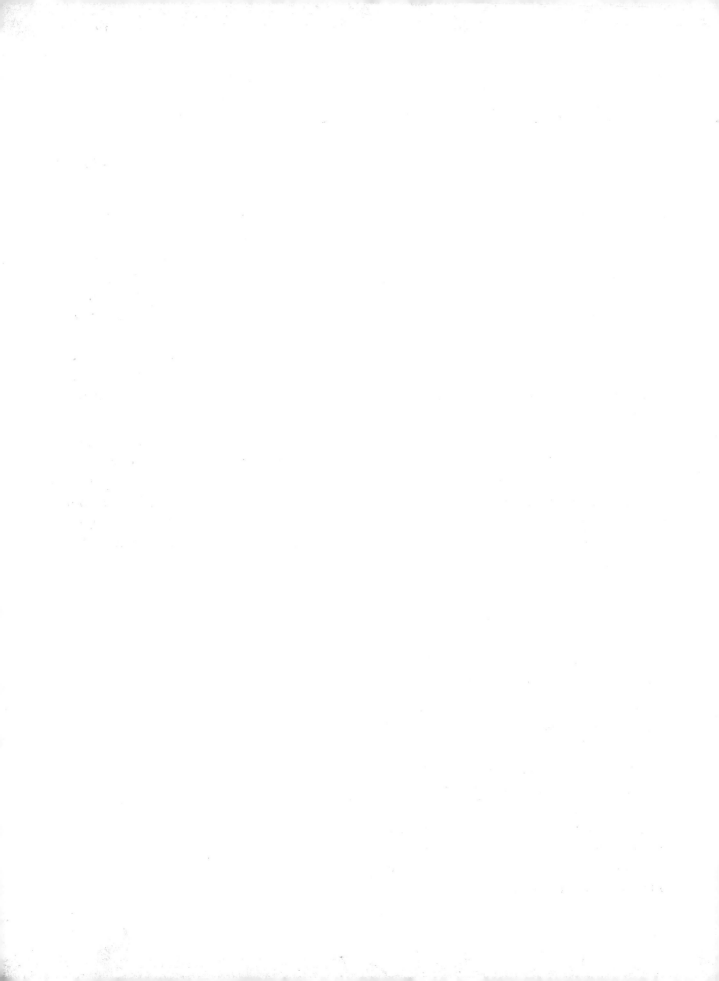

Decorative Painting

by Judy Balchin

So what exactly is meant by decorative painting? Well, let us try to imagine a world where it does not exist – where all surfaces are plain with no decoration. Difficult, isn't it? For thousands of years, people have had an irresistible desire to decorate things, from cave walls and pottery to buildings, furniture and fabrics. Throughout history we have been attracted to pattern and colour, and today you only have to look around your own home, or visit your local shopping centre, to see a wonderful variety of decorative colours and shapes.

Before starting the projects in this section, take a little time to look at the types of decoration used by different civilisations and countries. Each one has its own colour preferences and style. This can be seen when you look at floral designs. Flowers have always been popular as a subject, but compare the simple, stylish Lotus flower designs of ancient Egyptian artists with the intricate blossoms created by the Chinese. Both are beautiful, but very different.

You do not have to look far to find things to decorate and you do not have to spend a lot of money on them. We use flowers to decorate a box in the following pages, but we also have great fun decorating eggs with monsters and pebbles with animals. Wooden spoons are decorated with insects and colourful patchwork squares are painted on a glass jar to transform it into a fancy sweet container.

I will show you how to paint on different surfaces, including wood, paper, cardboard, terracotta, glass and stone. All the objects can be found easily, in or around your home. Cardboard boxes, paper plates, used containers and many other objects can be transformed with a little paint and some imagination. Acrylic paints have been used in every project, as these are inexpensive, cover the surface and are hard-wearing.

I have had great fun writing this section, and hope that as you work through the projects you will think of other ways of decorating surfaces. Look out for unusual things to paint. Be bold with your designs, use bright colours and have lots of fun!

Techniques

Decorative painting is not difficult to do, but it is worth reading through this section carefully before you start. The techniques are demonstrated on a cardboard box. Always clean brushes thoroughly in water after using them.

Note Decorative painting can be messy so it is best to cover your work surface with a large piece of newspaper.

Painting

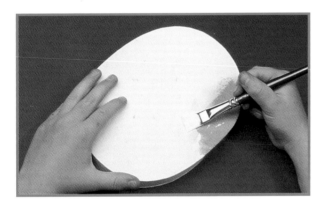

Use a flat brush to paint large surfaces. This gives an even finish which is easier to work on. Sometimes, you may need to apply two coats of paint, so the surface is well covered. Allow the first coat to dry before applying the second.

Splattering

Protect the work surface with newspaper. Dilute some paint on a palette with water so that it is runny. Dip the bristles of a toothbrush in the paint. Hold the toothbrush with the bristles towards the surface you are decorating and run your finger along the brush. This will splatter random paint spots on to the surface.

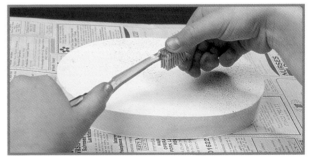

Masking and sponging

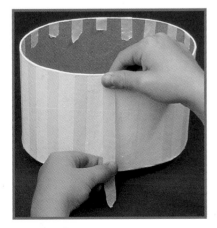

To mask areas of an object, press strips of masking tape on to the surface. Make sure that the edges of the tape are smoothed flat. The masked areas will remain the base colour.

When sponging, pour a little paint on to a palette. Dip the sponge in the paint, then dab the surfaces of the base and lid all over. Remove the masking tape to reveal neat stripes.

Stencilling, painting and outlining

Now that the surfaces have been prepared with flat colour and textured effects, images can be added. Stencils are a quick and easy way to create pictures which can then be added to and outlined.

1 Tape the stencil to the surface with small pieces of masking tape. Use a sponge to dab the paint through the stencil. Remove the stencil.

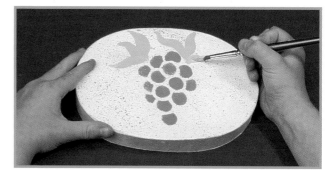

2 Paint in the pattern using a small paintbrush. Pull the brush towards you smoothly, lifting it off the surface as you complete the stroke to create a neat shape.

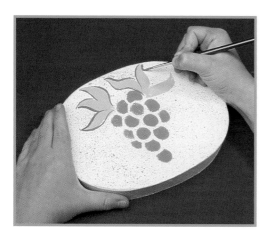

3 Outlining with black paint makes images really stand out. For this design, use a small round paintbrush to outline the leaves and the left-hand side of the grapes. This will create a three-dimensional effect.

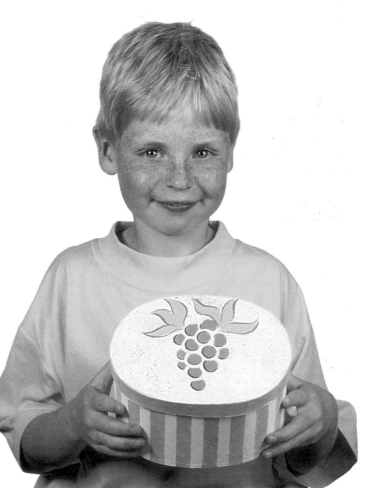

Bumble Bee Spoon

The insect world is fascinating and amazing. Think of the bee, the ladybird and the butterfly – they are all so different. Their amazing range of shapes and colours is not accidental. The insects use them as a defence against enemies and to attract other insects. In this project a bee motif is used to decorate a wooden spoon, and the same colours are used on the handle. Wood is a wonderfully smooth surface to paint on. If your spoon is a little rough, sand it down with sandpaper before starting.

YOU WILL NEED
Wooden spoon
Coloured acrylic paint
Large and small paintbrushes
Varnish • Tracing paper
Transfer paper
Masking tape • Pencil
Coloured ribbon

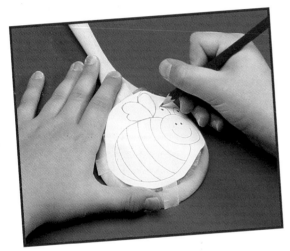

 Transfer the pattern on page 105 on to the back of the spoon (see page 104).

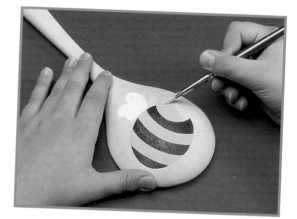

2 Paint the black stripes and then paint the bee's body and head using a small paintbrush and a light colour. Leave to dry.

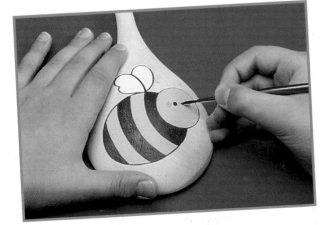

Paint the bee's cheeks, then carefully outline the bee in a dark colour. Paint in the eyes, mouth and antennae.

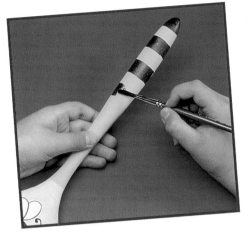

Paint the handle in the lighter colour. When it is dry, paint in the darker stripes.

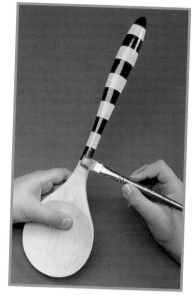

5 Use a larger paintbrush to varnish the back of the spoon. When the varnish is dry, turn the spoon over and repeat on the front.

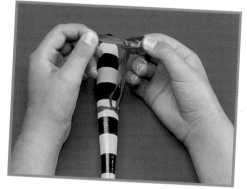

6 Tie a coloured ribbon around the handle so that you can hang it up.

Note This bumble bee spoon is purely decorative and should not be used to cook or eat with.

FURTHER IDEAS
Copy paintings of other brightly coloured insects and make your own colony of insect spoons.

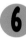

Rosy Gift Box

Artists have painted and decorated surfaces with flowers for a long time, inspired by the beautiful colours and shapes they have found in nature. Many fine examples of flower paintings can be found in museums and art galleries. These simple roses are easy to paint. They are used to transform a plain cardboard container into a lovely gift box. Look for an old box to decorate – you do not have to buy one.

YOU WILL NEED
Cardboard box
Black acrylic paint
Coloured acrylic paint
Large and small paintbrushes
Sponge • Palette

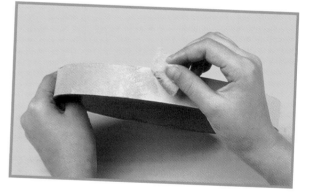

1 Use a large brush to paint the box and lid with a pale colour. You may need to apply two coats if the first one does not cover the surface completely. Make sure that the first coat is dry before applying the second.

2 Pour a small amount of a darker colour into a palette. Dip the sponge in the paint and dab it around the base and rim of the lid. Leave to dry.

3 Using a smaller brush and the same colour, paint circles all over the lid and box. Leave to dry.

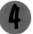

4

Paint leaf shapes around the circles using a different colour. Try to fill in any gaps. Leave to dry.

5

Decorate each coloured circle with a large swirl using black paint and a small paintbrush. Allow to dry.

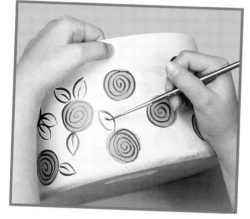

6

Outline the leaves with black paint and add a vein line down the centre of each one.

FURTHER IDEAS

Decorate boxes with different flowers – daisies, sunflowers and poppies. Keep the designs simple and use bright colours.

Sun Wall Hanging

Astrology is the study of the Sun, Moon, planets and stars, and the way they influence our lives. Astrological symbols have been used as decoration by artists and craftspeople throughout the ages. The Sun is ninety-three million miles away from Earth, but you can bring it right into your own home by creating this colourful Sun wall hanging. A paper plate is the perfect round blank on which to work. The basic design is painted and then decorated with dots and swirls of metallic paint.

YOU WILL NEED
Paper plate
Coloured and metallic acrylic paint
Large and small paintbrushes
Tracing paper • Transfer paper
Masking tape • Pencil
Scissors • String

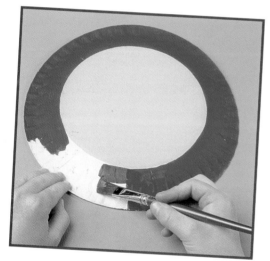

Note Place your plate over a roll of masking tape. This will help support the plate when you are painting it.

 Using a large paintbrush, paint the centre of the plate in a light colour and the border in a dark colour. Leave to dry.

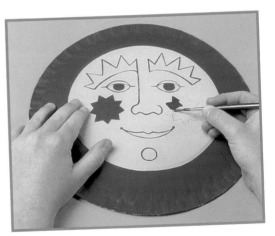

 Transfer the pattern on page 105 on to the centre of the plate (see page 104). Using a small paintbrush, outline the features in a dark colour, then paint in the eyes and cheeks. Leave to dry.

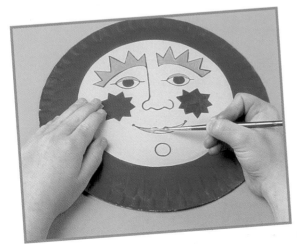

 Paint the eyebrows, eyelids, lips and chin with a lighter colour. Allow to dry.

90

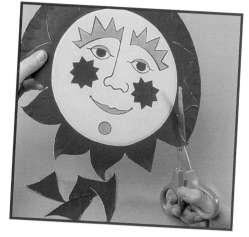

 Use a pencil to draw the Sun's rays around the border. Carefully cut them out.

5

Decorate the Sun's face with dotted swirls of metallic paint. Add dotted swirls to the rays. Leave to dry.

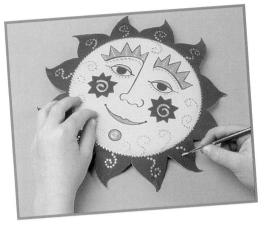

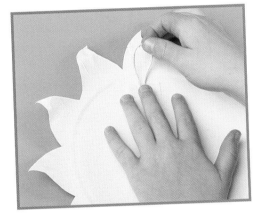

6 Tape a loop of string to the back of the top ray so that you can hang up your Sun.

FURTHER IDEAS
Make Moon and star wall hangings to complement your Sun – or decorate lots of small plates and create a matching mobile.

Patchwork Sweet Jar

For generations, people have created patchwork using scraps and odd remnants of material. You may have seen beautifully stitched quilts made in this way. They are usually made to commemorate an event or special occasion, such as a wedding. In this project we use paint to create our own patchwork. An old glass jar is decorated and transformed into a stylish sweet container. Look for a large jar to show off your painting. Do not forget to wash and dry it thoroughly before you begin.

YOU WILL NEED
Large glass jar
Black and white acrylic paint
Coloured acrylic paint
Large and small paintbrushes
Pencil • Varnish • Sweets
Coloured fabric • Scissors
Elastic band
Coloured ribbon

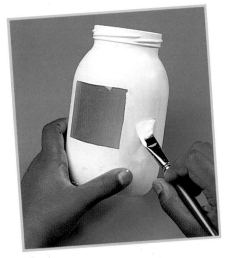

1

Paint the jar with two coats of white paint using a large brush. Leave an unpainted square in the middle, so when the jar is finished you can see what is in it. Let the first coat of paint dry before applying the second coat.

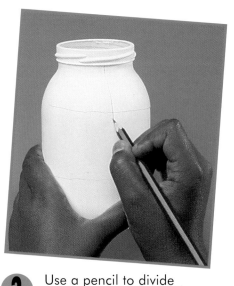

2 Use a pencil to divide the jar up into squares.

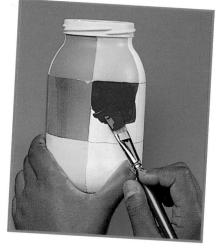

3 Paint the neck of the jar using a large paintbrush and a bright colour. When the jar is dry, paint in the squares using different colours. Leave to dry.

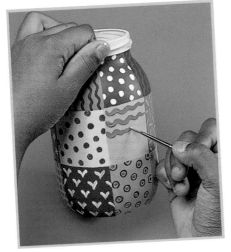

Add stitch lines around each square using a fine paintbrush and black paint. Leave to dry, then paint a coat of varnish on to the jar using a large brush.

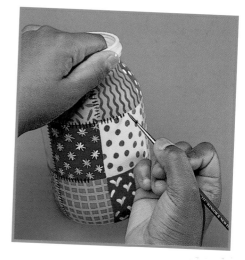

 4 Decorate each square with dots, lines or hearts. Try to make each one different.

FURTHER IDEAS
Recycle old bottles and create colourful patchwork patterns on them — or decorate other glass objects.

 6 Fill the jar with sweets. Cut out a circle of fabric double the size of the top of the jar. Secure the fabric around the top with an elastic band. Finally, tie a ribbon over the elastic band.

Padlocked Money Box

This project uses *trompe l'oeil*, a French term that means 'deception of the eye'. It refers to something that looks real, but is not – it is just an illusion. The padlock and chain on this money box look real, but they are just painted on. Painted shadow lines and highlights make them look three-dimensional.

YOU WILL NEED

Cardboard tube with plastic lid
Black and white acrylic paint
Metallic acrylic paint
Large and small paintbrushes
Toothbrush • Palette • Tracing paper
Transfer paper • Masking tape
Pencil • Newspaper
Craft knife • Cutting mat

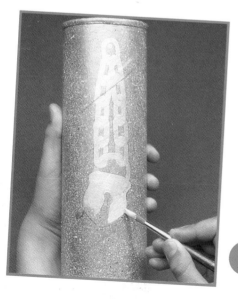

1

Paint the tube with white paint using a large brush and allow it to dry. You may have to apply a few coats of paint to cover any lettering. Wait for the last coat to dry, then apply two coats of metallic paint.

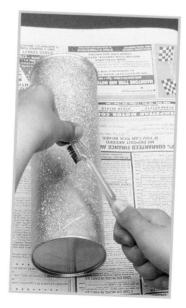

2

Cover the work surface with sheets of newspaper. Lay the tube on top. Pour small amounts of black and white paint into a palette and dilute them both with water. Using a toothbrush, splatter the tube first with white, then with black paint (see page 84). Roll the tube to make sure that you splatter the whole surface.

3

Transfer the pattern on page 106 on to the tube and fill it in with metallic paint. Leave to dry.

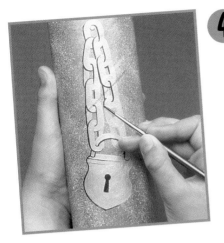

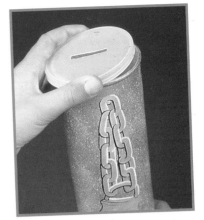

4 Using a small paintbrush, paint the keyhole. Add black shadow lines down the left-hand side and along the bottom of the chain links and padlock. Leave to dry.

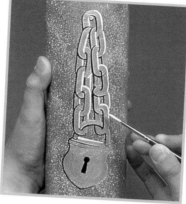

6 Cut a slot in the top of the lid with a craft knife, then place the lid on top of the tube.

!

A craft knife is very sharp; it should always be used with a cutting mat. Ask an adult to help you.

5

Paint white lines down the right-hand side and along the tops of the links and padlock, to create highlights.

FURTHER IDEAS

Design some symbols that mean 'Keep out', 'Private', 'Danger' and use these to decorate your money box.

Tiger Paperweight

Decorating pebbles or stones is an unusual and fascinating craft, and it is easy to do. Part of the fun is finding just the right shape. Look for a pebble or stone that suggests the shape of a tiger, and make sure that it has a smooth surface, as this will be easier to paint. Keep your design simple and use bold colours for the best effect.

YOU WILL NEED

Pebble
White and black acrylic paint
Coloured acrylic paint
Large and small paintbrushes
Pencil • 2 plastic eyes
PVA glue

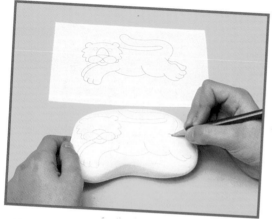

 1 Paint the pebble white using a large paintbrush. Leave to dry. Copy the pattern from page 106 on to the pebble using a pencil.

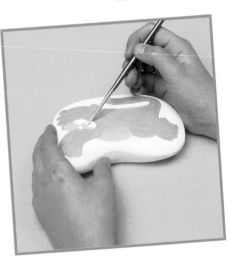

2 Using an appropriate colour, paint in the darker areas of the body, then paint in the lighter areas.

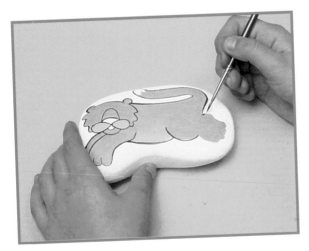

3 Outline the tiger using a small paintbrush and black paint.

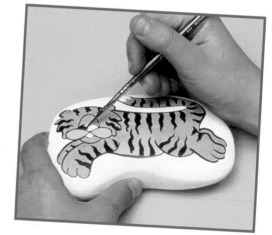

 4 Add the stripes, nose and mouth using a small paintbrush and black paint. Leave to dry.

5 Glue on the plastic eyes using PVA glue. Leave to dry.

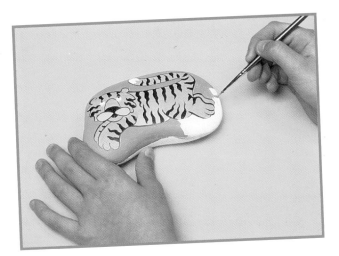

6 Paint the rest of the pebble in a bright colour. Leave to dry.

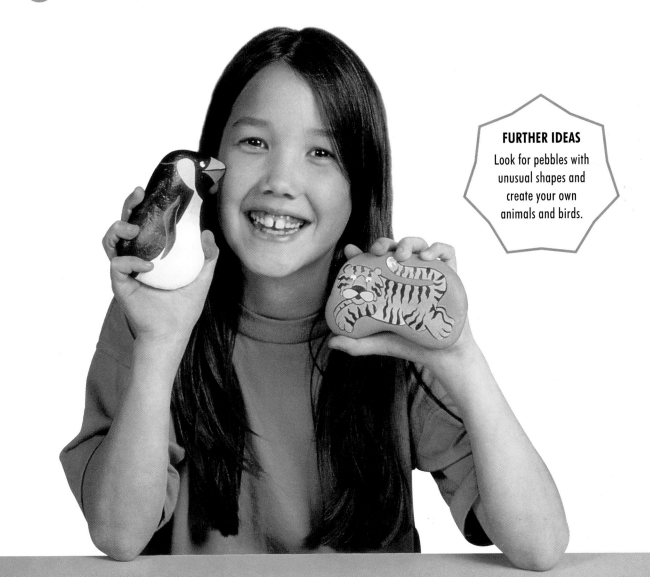

FURTHER IDEAS
Look for pebbles with unusual shapes and create your own animals and birds.

Fruity Flower Pot

Artists and craft workers have always used fruit motifs as decoration because of the amazing variety of shapes and colours they offer. Try making a list of all the fruits you can think of, and you will soon realise what a wonderful choice there is – oranges, apples, strawberries, lemons, grapes and more! This fruity project combines masking with sponging and stencilling – easy techniques that transform a plain terracotta pot into a colourful decorative plant container. Use an inexpensive sponge and tear pieces off as you need them.

YOU WILL NEED
Terracotta pot
Coloured acrylic paint
Large paintbrush • Palette
Thin card • Tracing paper
Transfer paper
Narrow masking tape
Pencil • Sponge • Scissors
Old cloth

 Paint the pot in a light colour using a large paintbrush. Leave to dry. Apply vertical strips of masking tape around the pot (see page 84). Try to make the gaps between the strips the same.

 Pour some darker coloured paint into a palette and sponge the unmasked stripes (see page 84). Carefully remove the masking tape and leave to dry.

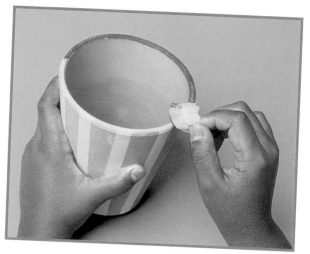

 Carefully sponge the top of the rim and the base of the pot with a different colour.

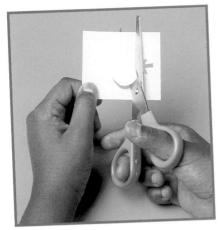

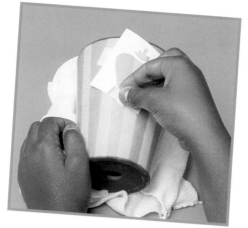

5

Lay the pot down on an old cloth to stop it rolling around. Tape the stencil on to the pot with masking tape.

4
Transfer the strawberry pattern on page 105 on to thin card. Cut out the strawberry shape to create a stencil.

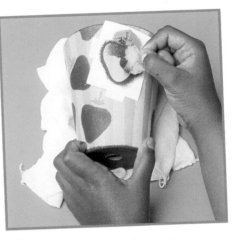

6
Sponge paint through the stencil on to the pot. Choose two appropriate colours and use two pieces of sponge to colour the top of the strawberry, then the fruit. Work around the pot varying the angle of the strawberries.

FURTHER IDEAS
Change your designs by painting horizontal stripes around your pot and choose other types of fruit.

Monster Egg

An artist called Carl Fabergé created beautifully decorated eggs in the late nineteenth century. Some of his more precious jewelled eggs were made for the Russian royal family. I have used a hard boiled egg for this project and created an optical illusion. Although the monster is painted on the surface of the egg, it looks as though he is living inside it! If you want projects to last a long time, polystyrene or papier mâché eggs can be decorated using the same techniques.

YOU WILL NEED

Hard boiled egg
Black acrylic paint
Coloured acrylic paint
Large and small paintbrushes
Pencil • Egg cup

Ask an adult to boil the egg for you before you start the project.

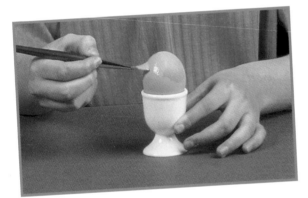

1 Paint the top half of the egg in a colour of your choice using a large paintbrush. Sit it in an egg cup and leave it to dry. Turn it over and paint the bottom half. Leave to dry. Take care not to get paint on the egg cup.

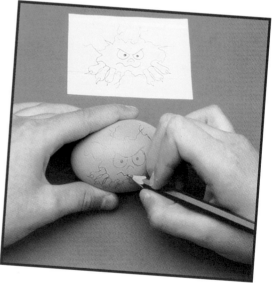

2 Copy the monster pattern from page 106 on to the egg using a pencil.

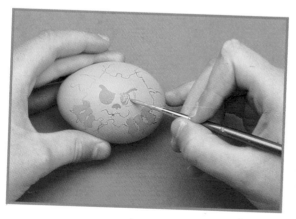

3 Paint the fingers using a brighter colour. Mix a touch of black with this colour to darken it and paint in the nose and eyes with a small paintbrush. The darker colour will make it look as though the monster is hiding in a shadowy hole.

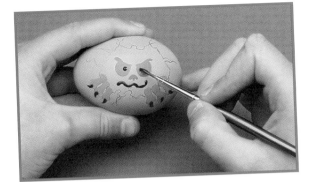

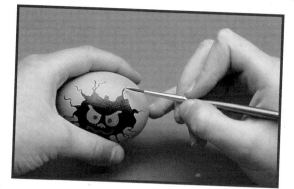

 4 Add the claws, mouth and staring eyes using another bright colour.

 5 Fill in the area behind the monster's features using black paint. Outline the fingers with the same paint, then add the lines around the edge of the hole.

Paint a thin white line along one side and along the bottom of the hole. Paint small white dots at the base of the fingers. This gives the appearance of highlights which makes the monster look even more three-dimensional.

6

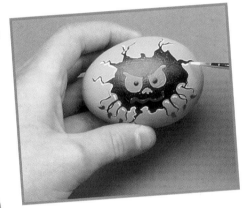

FURTHER IDEAS
Use metallic acrylic paints to create realistic alien eggs, or invent your own monster.

Picasso Mirror

This project is inspired by the work of the Spanish artist, Pablo Picasso. He was born in 1881 and was one of the greatest painters of the twentieth century. You can use the style and colours of his work to create your own masterpiece. Before you start, take time to look at Picasso's work.

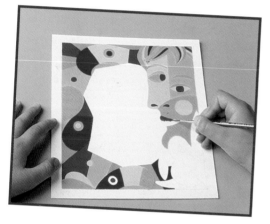

1 Transfer the pattern from page 107 on to card (see page 104). Using bright colours and a small paintbrush, start filling in the design.

2 Continue painting the frame until all the areas are filled in.

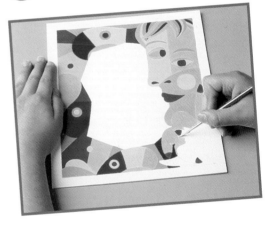

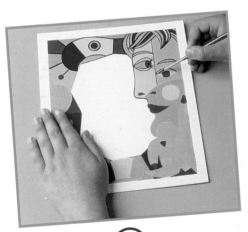

3 Outline the design using black paint. Leave to dry. Cut off the outer unpainted border using a craft knife. Cut out the unpainted central section.

> (!) A craft knife is very sharp and it should always be used with a cutting mat. Make sure you ask an adult to help you when you use it.

4 Paint the outside and inside edges of the cut card black.

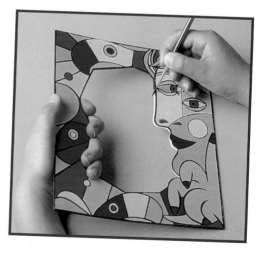

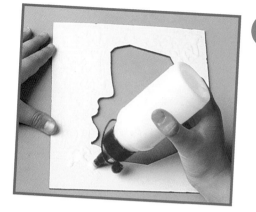

5 Using scissors, cut a piece of mirror card to the same size as the frame. Spread the back of the frame with a thin layer of glue.

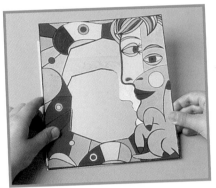

6 Carefully press the frame down on to the mirror card, matching all the corners. Leave to dry.

Note While the glue is drying, place a heavy book on top of the frame to prevent warping.

7 Tape a loop of string to the back of the frame with masking tape, so that you can hang up your mirror.

FURTHER IDEAS
Look at the work of other famous artists. Decorate photograph frames or mirror frames in their style.

Patterns

You can trace the patterns on these pages straight from the book (step 1). Alternatively, you can make them larger or smaller on a photocopier if you wish, and then follow steps 2–4.

> (!) Ask an adult to help you enlarge the patterns on a photocopier.

 1 Place a piece of tracing paper over the pattern, then tape it down with small pieces of masking tape. Trace around the outlines using a soft pencil.

2 Place the tracing paper or photocopy on the surface of the project and tape it at the top. Slide the transfer paper underneath and tape it at the bottom.

3 Trace over the outlines with the pencil, pressing down firmly.

4 Remove the tracing paper, and the transfer paper, to reveal the design.

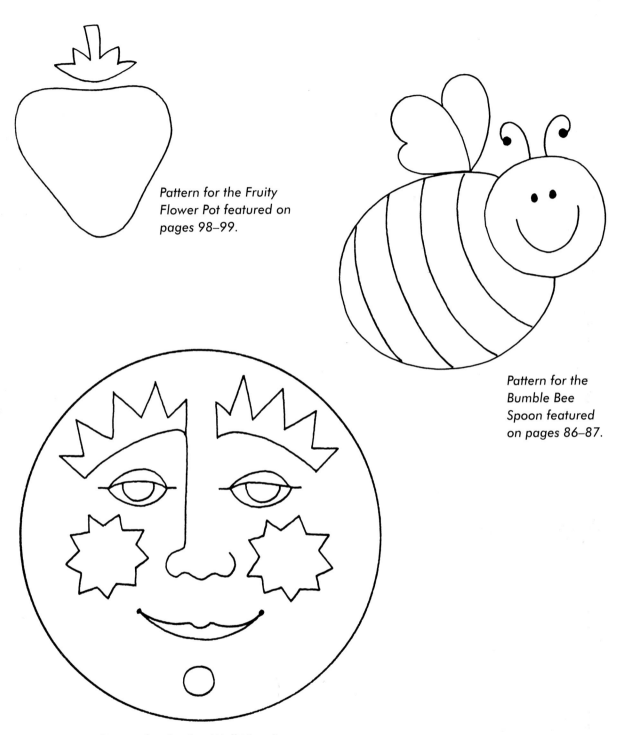

Pattern for the Fruity Flower Pot featured on pages 98–99.

Pattern for the Bumble Bee Spoon featured on pages 86–87.

Pattern for the Sun Wall Hanging featured on pages 90–91.

Pattern for the Monster Egg
featured on pages 100–101.

Pattern for the
Padlocked Money Box
featured on pages
94–95.

Pattern for the Tiger Paperweight
featured on pages 96–97.

Pattern for the Picasso Mirror featured on pages 102–103.

Papermaking

by David Watson

Papermaking is one of the oldest crafts. It was accidentally discovered in China around 105 AD by Ts'ai Lun, an imperial court official. He noticed that some old rags that had been left out in the rain had been broken down by the continuous pounding of passers-by, and had eventually dried to a hard flat sheet in the sun. Old fishing nets, ropes and rags were later used to make paper.

At first, paper was made for official documents and religious propaganda by the Chinese, Japanese and the nations of Islam. It eventually reached Europe around the twelfth century AD. The invention of the printing press in the early fifteenth century increased the demand for paper almost overnight. In Europe, the favoured material for papermaking was old rags that were bleached white. This tended to standardise the look of hand-made paper and make it appear rather bland. Some papermakers in places like Japan and Nepal continued to use a variety of plant fibres and as a result their hand-made paper looked much more beautiful.

When I was about ten years old I was given a sheet of European hand-made paper by my art teacher. It was yellowy white, quite stiff, with funny wavy edges. The texture looked something similar to that of an old blanket and it had a funny smell. I really wanted to cut off those edges and make it look neat. I was told that it was very special and very expensive. I felt so frightened of this piece of paper that I stuck it in a drawer, unable to use it for years and years. It is probably still there now.

Much later, somebody introduced me to a papermaker called Maureen Richardson and showed me some of her papers. 'That's not paper,' I said, 'it looks exciting, colourful and almost good enough to eat.' But it was paper. Maureen showed me how to make it and I was hooked. I could not believe the difference between that and the old stuffy, smelly and frightening piece of hand-made paper I had seen when I was younger.

This section contains lots of exciting techniques and projects. The materials always come from recycled or reclaimed sources where possible, and most of the equipment can be found at home. This section is about breaking the rules and having fun, so let's get started!

A **mould** and **deckle** are items made specially for papermaking. The mould is a frame covered with a mesh screen, and the deckle is a simple frame, the same size as the mould. Both these things can be bought from craft shops.

Techniques

The projects all follow the basic techniques shown here, with only slight variations. These techniques are based on traditional methods that are still used in hand-made paper mills today. Practise them until you are happy with your results, then you can start being really creative.

Note Exact paper quantities are not given. They will vary according to the type of paper that you are pulping. Generally, the more absorbent the paper is, the less you will need of it.

Making pulp

Paper can be broken down into tiny fibres by blending it into a pulp with water. The paper fibres are joined together again to form new sheets during the papermaking process. The colour of the paper you use for pulp will determine the colour of the new sheets.

 Prepare scrap paper for pulping by tearing it into 2.5cm (1in) squares.

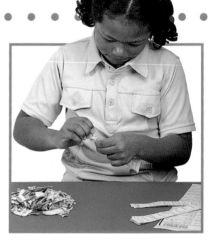

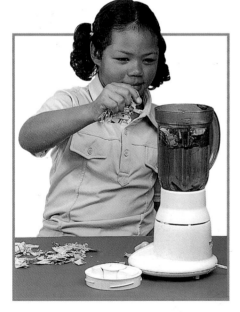

 Food blenders have very sharp blades. Always ask an adult to help you use one.

2 Fill the food blender two-thirds full of water, then add a small handful of torn paper. Blend the mixture for approximately ten seconds.

Note Take care not to put too many pieces of paper in the food blender. You will know if you have because the sound will change if it is overloaded.

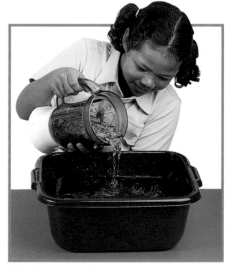

3 Pour the blended pulp into a washing-up bowl half-full of clean water. Repeat these steps three more times.

Making a couching mound

A couching mound is a base on which you make your paper. You can make a couching mound out of a pile of wet newspapers.

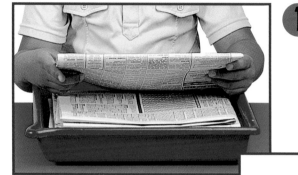

 1 Once you have prepared the pulp, you need to build up a couching mound. To do this, fold up five whole newspapers so that they are small enough to fit in a shallow plastic tray. Stack them in the tray, alternating the folds from one side of the pile to the other.

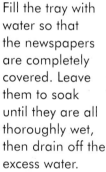 **2** Fill the tray with water so that the newspapers are completely covered. Leave them to soak until they are all thoroughly wet, then drain off the excess water.

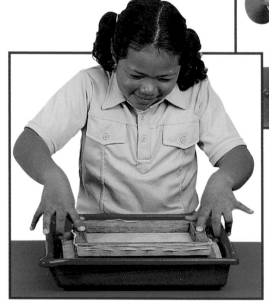

 3 The couching mound should have a smooth surface that is slightly higher in the middle than at the edges. Press and rock the mesh screen on the mould across the top to make this shape.

 4 Place a clean kitchen cloth over the couching mound to cover it.

From pulp to paper

This demonstration shows how to make one sheet of paper, but you can repeat the technique to make lots of sheets.

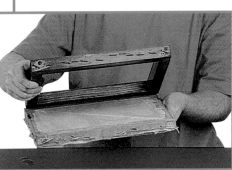

1 Once you have prepared the pulp and the couching mound you are ready to make your paper. Begin by stirring the pulp mixture vigorously with your hands.

2 Use a sponge to thoroughly wet the mesh screen on the mould. Then, hold the mould with the screen uppermost and place the deckle on top.

3 Insert the deckle and mould into the pulp mixture, right at the back of the bowl. Take them down to the bottom, and level them out.

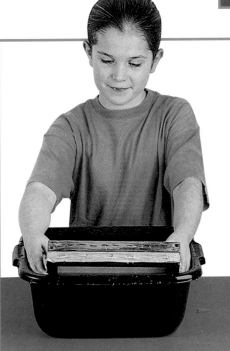

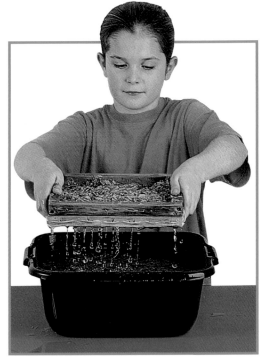

Note Steps 3 and 4 should be one steady, continuous movement.

4 Pull the deckle and mould out of the mixture, making sure they stay level at all times.

 5

Carefully lift the deckle off the mould. Make sure that water does not drip on to the fibres, or your paper could be damaged.

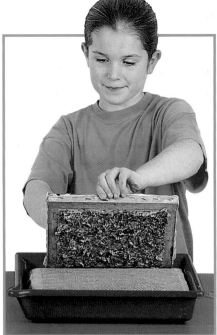

6

Turn the mould over then carefully position the front edge of the mould along the front edge of the couching mound.

Note Steps 7 and 8 should be one continuous movement.

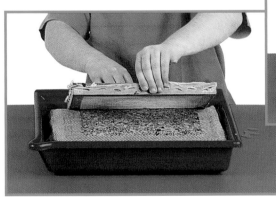

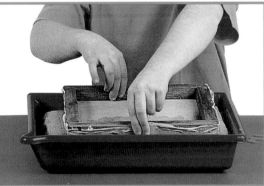

 7

Roll the mould down on to the couching mound then press the far edge of it firmly into the mound.

8

Holding the edge of the mould nearest to you firmly down on the mound, roll the other edge back, transferring the wet paper fibres on to the kitchen cloth.

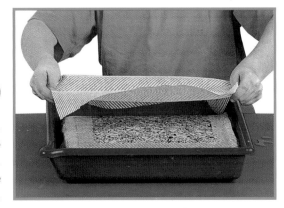

9

Place a clean kitchen cloth over the fibres, making sure that it is completely flat, with no creases. Your first sheet of paper is now complete. Place another kitchen cloth on top, ready to make the next sheet of paper (see step 4, page 111).

Pressing and drying the paper

You may find it best to work outside when pressing paper. A lot of water will be squeezed out when you stand on the boards, and it can be quite messy!

1 Place a wooden board on the floor and lay two whole dry newspapers on top. Carefully transfer your newly-formed sheet(s) of paper with kitchen cloths from the couching mound on to the dry newspapers.

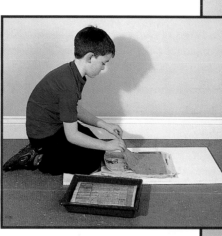

2 Place more dry newspapers and another board on top, then carefully stand on the boards, increasing the pressure slowly. Add more weight by asking your friend or an adult to help!

3 Remove the top board and the newspapers, then separate each set of two kitchen cloths, keeping a sheet of newly-formed paper in between. As this photograph shows, you do not have to worry about bending the sheets – by now the fibres will have joined together to form flexible sheets of paper.

4 Leave the sheets of paper to dry within the kitchen cloths on flat dry newspapers. Alternatively, you could hang them out to dry on a washing line.

 When your paper feels dry and rigid, carefully remove the top kitchen cloth – this should peel off quite easily. Insert your thumb under a corner of the sheet of paper and slide it along one edge to begin to remove it from the bottom kitchen cloth.

6 Repeat step 5 on an adjacent edge. Hold the free corner of the paper in one hand and carefully peel the paper away from the kitchen cloth.

Sparkly Birthday Card

Cards became popular during the Victorian period when the first festive Christmas cards were produced. You can now buy a card for almost any occasion. This birthday card is made using the techniques shown on pages 110–115, but small sparkly shapes and a person's age are added. The shapes bond together in the dried sheet and the image is fixed on to the paper as it is being made.

YOU WILL NEED

White paper • Food blender
Washing-up bowl • Plastic tray
Newspaper • Jug • Mould and deckle
Sponge • 2 wooden boards
2 kitchen cloths • Glitter confetti
Thin coloured paper
Tea strainer • Pizza cutter
Ruler

 1 Prepare some white paper pulp and a couching mound (see pages 110–111). Insert the deckle and mould into the pulp (see page 112), but rather than lifting them right out, bring them up level with the surface of the pulp and stop. Ask a friend to sprinkle glitter confetti over the deckle.

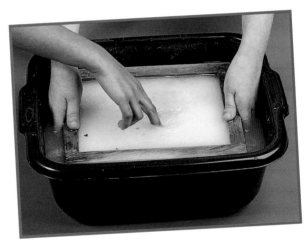

2 Separate the pieces of confetti if necessary, then slowly lift the deckle and mould out of the pulp and allow the water to drain out.

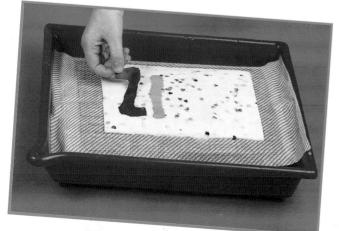

 3 Carefully remove the deckle from the mould and turn the wet paper fibres out on to a couching mound. Tear some numbers out of thin coloured paper, then place them on one half of the wet paper fibres.

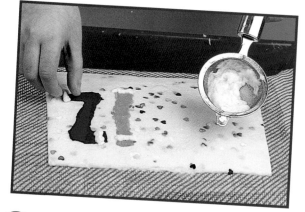

4 Use a tea strainer to remove some paper fibres from the pulp in the bowl. While the fibres are still very wet, place a thin line of them across each end of the numbers.

5 Cover with another kitchen cloth, then press and dry the paper (see pages 114–115). Use a ruler to mark the middle of the sheet then go over that line with a pizza cutter. Fold the paper in half to complete your card.

FURTHER IDEAS
Experiment with using seeds or leaves instead of glitter confetti – in fact, you can mix almost anything you like with the paper fibres.

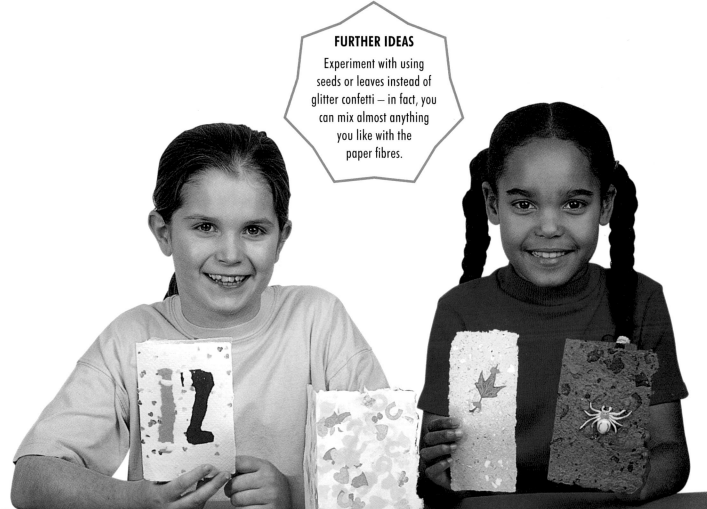

Fancy Folder

Wonderful historical examples of patterned and textured paper can be seen in museums today. It is easy to recreate these effects using modern materials. Wire is used to make the design on this folder – it is bent into a design and placed under the wet paper fibres. Ribbons are placed between two layers of paper fibres. When the paper is dry, the wire is removed.

1 Bend a length of copper wire into a shape of your choice using a pair of pliers. The wire shape needs to be small enough to fit on to half of your sheet of paper.

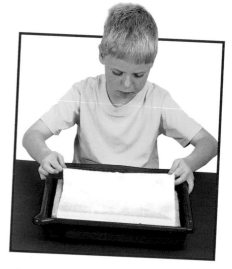

2 Prepare some pulp made from cartridge paper, and a couching mound (see pages 110–111). Place a piece of old thick blanket on top of the mound.

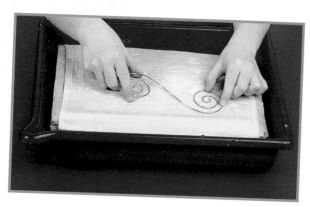

3 Place the wire carefully on to the blanket so that the pattern will appear on one half of the paper.

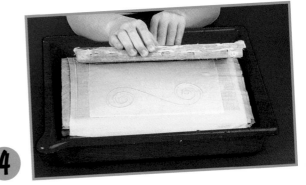

4 Take up a layer of fibres in the mould and deckle, then turn them out over the wire. Peel back the mould carefully (see pages 112–113).

6
Take up another layer of paper fibres then carefully turn them out on top of the first layer. Remove the mould, cover with another piece of blanket, then press and dry the paper (see pages 114–115).

5
Wet the ribbons then place them over the fibres, a little way in from the top and bottom edges of the paper.

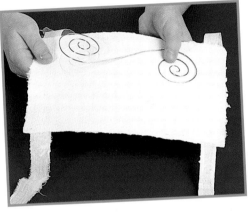

7
Remove the wire. Crease the middle of the sheet with a pizza cutter (see page 117) and fold it in half so that the raised pattern is on the front of the folder.

FURTHER IDEAS
Create your own patterns using different shapes – leaves, string or wire mesh. You can use anything that will make a mark.

Personal Paper

Watermarked papers became popular in Europe during the fifteenth century. You can only see a watermark when the paper is held up to the light. The marks made were usually of animals and fruits or simple shapes like the 'C' shown here. Why not make personalised paper with your own initials?

YOU WILL NEED
Cartridge paper
Thick and thin copper wire
Pliers to cut and bend the wire
Food blender • Washing-up bowl
Plastic tray • Newspaper
Jug • 2 kitchen cloths
Mould and deckle • Sponge
2 wooden boards

 Use pliers to bend a length of thick copper wire into a 'C' shape. Make sure it will lie flat on a level surface.

 Place the 'C' on the mould's mesh surface. Fold short lengths of thin copper wire in half then poke the ends down through the mesh, either side of the 'C'.

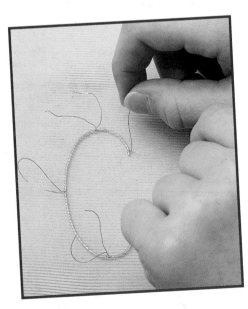

 Hold the 'C' in place then turn the mould over. Twist the ends of the fine wire together so that the 'C' is held securely in place.

4 Make a very fine cartridge paper pulp by blending it slightly longer than usual (see page 110).

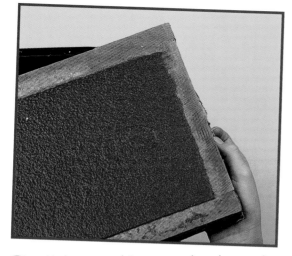

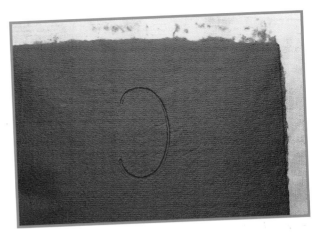

5 Make a couching mound and cover it with a kitchen cloth. Take up a layer of paper fibres in the mould and deckle, keeping them very level as you remove them from the pulp (see page 112).

6 Turn the paper fibres out on to the couching mound (see page 113). You should just be able to see the shape of the 'C' and there should be no bubbles or creases. Carefully cover the paper fibres with another kitchen cloth then press and dry the paper (see pages 114–115).

Note If you can still see the wire 'C', the pulp is probably too thin, so make the pulp slightly thicker and try again.

7 Hold your paper up to the light to see the watermark.

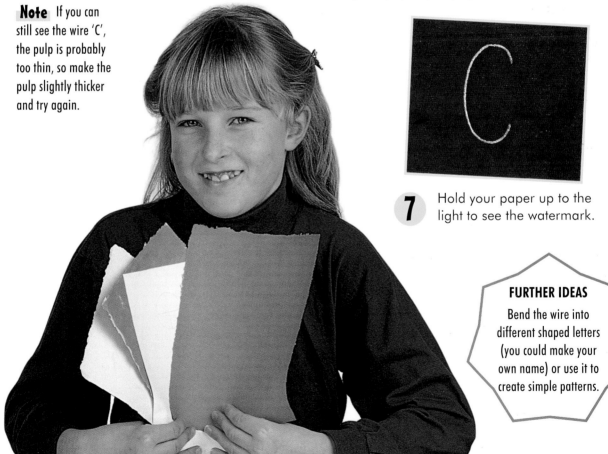

FURTHER IDEAS
Bend the wire into different shaped letters (you could make your own name) or use it to create simple patterns.

Feather Bookmarks

You can recycle all sorts of things and add them to the paper fibres – leaves, pieces of fabric, ribbons and more. Feathers are usually long and thin, so they make excellent bookmarks. This project allows you to make two bookmarks at once. You will need to prepare two bowls of pulp – one made from old printed paper and one from cartridge paper.

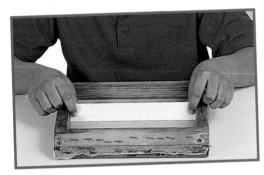

 Divide the deckle in half lengthways with a strip of foamboard.

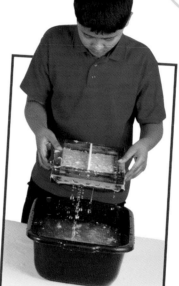

 Prepare the two bowls of pulp and make a couching mound (see pages 110–111). Cover the mound with cotton sheeting. Dip the mould and deckle in the printed paper pulp, lift it out and let the excess water drain off.

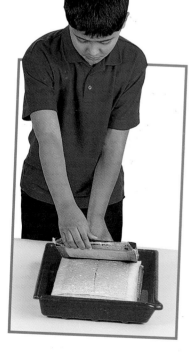

 Remove the deckle then turn out the layer of wet paper fibres on to the cotton sheeting.

4 Thoroughly soak the feathers in clean water, then place one on each half of the wet paper fibres.

5 Make another layer of pulp with the cartridge paper then turn the paper fibres out over the feathers. Cover this layer of fibres with cotton sheeting, then press and dry the paper (see pages 114–115).

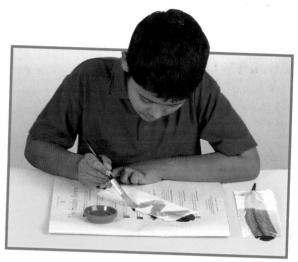

6 Apply a layer of varnish to the white side of the dry bookmarks, and watch the feathers magically appear.

FURTHER IDEAS

Add other things to the paper fibres instead of feathers. Try using sequins, pressed dried flowers or sparkling metallic threads.

Magic Picture Frame

Family photographs are often framed and displayed by proud relatives, or they are collected in treasured albums. If you have a favourite photograph you can show it off in this vibrant frame. Get an adult to help you colour-photocopy the photograph before you begin, making sure it is slightly smaller than the mesh on the mould. Two colours are used for this frame, and it combines magically with the photograph without you having to use any glue.

 1
Prepare one colour of pulp and a couching mound (see pages 110–111), then place a piece of cotton sheeting over the mound. Scoop up a layer of paper fibres and turn it out on to the cotton sheeting (see pages 112–113).

 2
Place the photocopy of your photograph on top of the wet paper fibres.

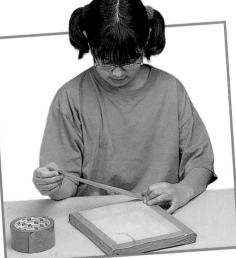

 3
Thoroughly dry the mesh screen on the mould, then stick strips of plastic parcel tape round the edge.

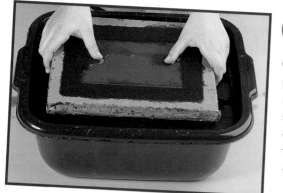

4

Cut a piece of acetate slightly smaller than the photocopied photograph, then place it on top of the mesh and hold it there with your thumbs. Prepare a second colour of pulp then dip the mould (without the deckle) into the pulp. Level it out under the surface, then carefully lift it out. The pulp will settle around the edges of the acetate.

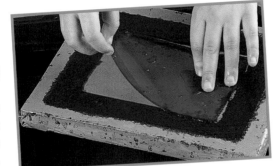

5

Carefully peel the acetate away from the paper fibres to leave a border.

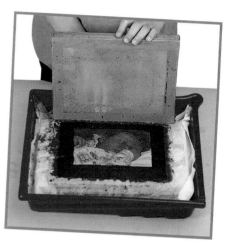

6

Turn the border out over the picture. Cover with another piece of cotton sheeting then press and dry the paper in the usual way (see pages 114–115).

FURTHER IDEAS
Choose different colours for your border, and add glitter confetti or pressed dried flowers to the paper fibres.

String-Along Book

You can recycle old paper to make this beautiful book, which can have as many pages as you like. The paper has a great texture and is perfect for chalk or pastel drawings, or you can simply write on it with a pen. You can make front and back covers for the book using thicker paper if you wish.

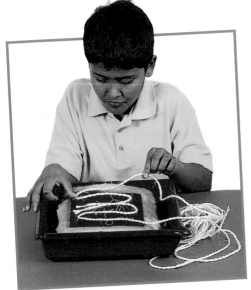

1 Prepare some pulp and a couching mound (see pages 110–111), then place a piece of old thick blanket on top of the mound. Turn out a layer of paper fibres on top (see pages 112–113). Thoroughly wet the string then cut it in half. Arrange one end of each length of string on the paper fibres as shown.

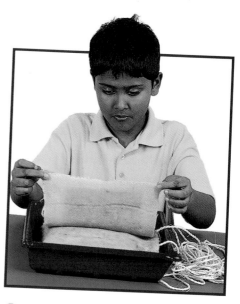

2 Turn out a second layer of paper fibres over the string to complete the first page of the book, then place two pieces of blanket on top.

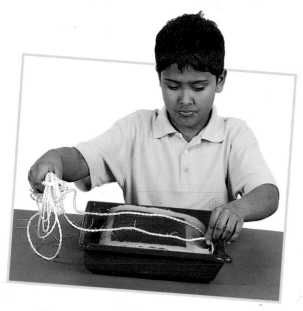

3 Make the first layer of paper fibres for the second page of the book. Take the string across the couching mound, leaving short loops on one side. Make the second layer of paper fibres then turn this out over the string.

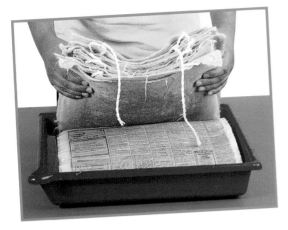

Note This stage can be a bit tricky, so do not hurry it.

4 Continue making more pages, moving the string from one side to the other, until you have made about ten pages. Lift the wet paper fibres and blanket layers on to a wooden board. Put another board on top and press out all the water (see page 114).

5 Place the pressed pile at one end of your work surface. Ask a friend to hold the bottom page down, then carefully open out the linked pages. Put dry newspapers below and on top of each page to soak up the moisture. Remove the pieces of blanket when all the pages are dry.

FURTHER IDEAS

Make the book into a large wall hanging by linking more sheets at the top and bottom as well as at the sides.

Funny Face Lampshade

This project shows you how easy it is to make your own lampshade. The pulp you will use is made from tracing paper. This has very short fibres, and all kinds of strange things happen as they dry. In fact, it is just about impossible to keep them flat!

Electricity and water can be very dangerous together. Ask an adult to disconnect the table lamp from the electricity supply before you start this project.

YOU WILL NEED

Low-energy light bulb, maximum 15 watt
Table lamp base • Tracing paper
1m (3½ft) of stiff copper wire
Pliers • Sticky tape • Food blender
Washing-up bowl • Plastic tray
Newspaper • Jug • Mould and deckle
Sponge • Old thick blanket
2 wooden boards

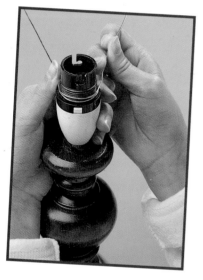

1 Take the copper wire and place the centre of it against the lamp fitting. Carefully wrap it once around the base of the fitting.

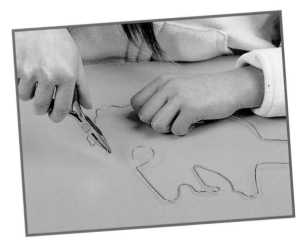

2 Loosen the wire carefully from around the base of the lamp fitting and remove it, taking care not to alter the shape. Use the pliers to bend the rest of the wire into an interesting face shape. Make sure the neck is at least 7.5cm (3in) long.

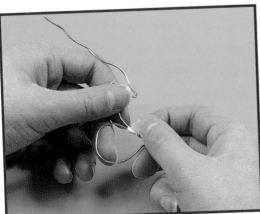

3 Join the two ends together with sticky tape.

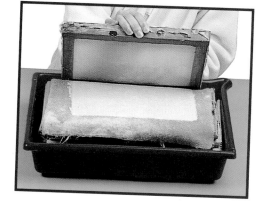

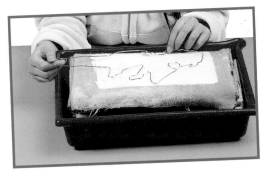

Place the wire shape over the first layer of paper fibres, leaving the neck end free.

4 Prepare some tracing paper pulp and a couching mound (see pages 110–111), then place a piece of old thick blanket on top of the mound. Turn out a layer of paper fibres on to the blanket (see pages 112–113).

Note The tracing paper pulp should be finely blended for this project.

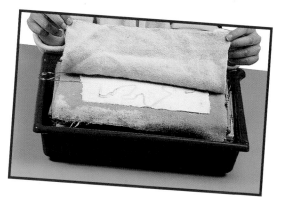

6 Turn out another layer of paper fibres over the wire shape. Carefully place a second piece of blanket on top, then press and dry thoroughly (see pages 114–115). Ease the wire back over the lamp fitting then bend the paper up in front of the light bulb.

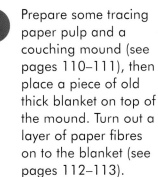

FURTHER IDEAS

Try making different wire shapes such as stars and moons, and add glitter to the paper fibres so that the lamp shade sparkles in the light.

Pulp Painting

You can create amazing paintings using pulp made from recycled coloured paper – swirls and circles of bright colour can be combined or blended to make abstract or realistic designs. The colours will lighten when they dry, so use really brightly coloured paper to make your pulp. In this project, the pulp is not diluted in a washing-up bowl. Instead, it is poured straight into the mould and deckle which sits in a shallow tray of water.

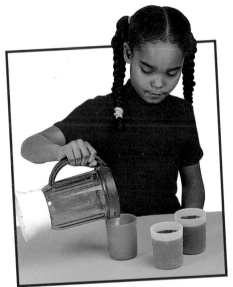

 Prepare three different colours of pulp (see page 110) then pour each colour into a cup. Make a couching mound (see page 111).

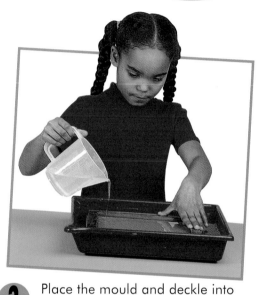

2 Place the mould and deckle into a shallow tray. Fill the tray with water until it is almost level with the top of the deckle.

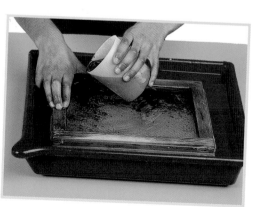

3 Hold the deckle down to stop it floating off the mould, then pour one colour of pulp into the deckle, starting at one edge.

 Add another colour of pulp, leaving a space between the two colours. Add the third colour in the same way.

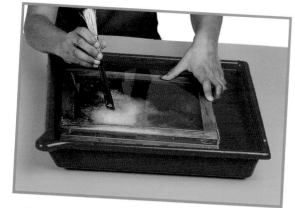

5 Use the end of a paintbrush to blend the colours together so that there are no gaps or holes. Add more pulp if necessary.

6 When you are happy with your picture, carefully lift the mould and deckle out of the water. Allow the excess water to drain away, then continue making the paper as shown on page 113. Press and dry the paper (see pages 114–115).

FURTHER IDEAS
Make more colours of pulp and use them to paint a simple landscape.

Patterned Paper

In this project you can recycle your paper to create vibrantly coloured patterns. A gravy baster or an empty squeezy bottle can be filled with coloured pulp and used to squirt out designs and shapes. The pulp has to be blended finely so it does not clog up the nozzle of the gravy baster. It will be just right when it looks and feels like soft ice-cream.

YOU WILL NEED

Coloured paper
Food blender
Plastic tray • 4 plastic cups
Gravy baster
Mould and deckle
Kitchen cloth

1 Make up four colours of pulp (see page 110) then pour each colour into a cup.

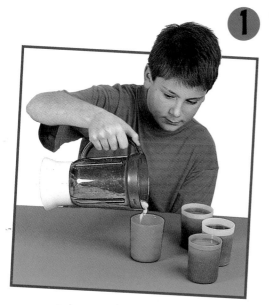

2 Place the mould in the tray and thoroughly wet the mesh with a kitchen cloth. Position the deckle on top of the mould.

3 Squeeze the end of the gravy baster then dip the nozzle into one of the colours of pulp. Gently release your hold to draw up the pulp.

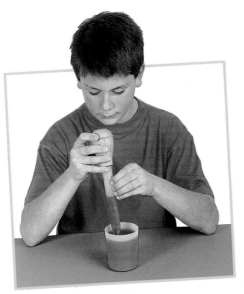

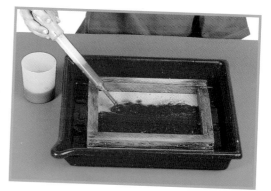

4 Move the gravy baster over the mesh then gently squeeze the end so that the paper fibres flow from the nozzle on to the mesh. Continue until you have covered it completely.

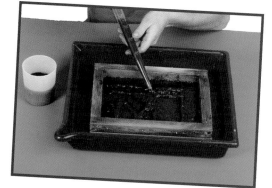

5 Clean the gravy baster with water. Change to a second colour of pulp and start painting your pattern.

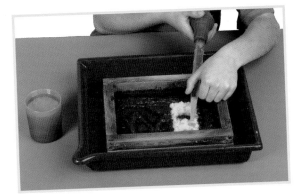

6 Continue adding the colours until you are happy with your pattern.

FURTHER IDEAS

Make a simple picture using this technique — try a boat on a stormy sea, a dinosaur or a fantasy landscape.

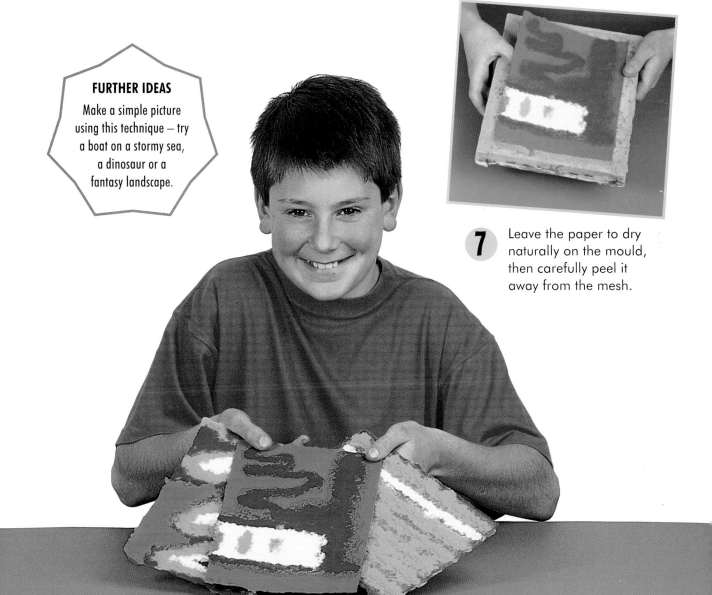

7 Leave the paper to dry naturally on the mould, then carefully peel it away from the mesh.

Paperfolding

by Clive Stevens

Paperfolding is not only an ancient art, but it is one that requires very little equipment or space. As long as you have paper, a pair of scissors and some glue you can create a variety of wonderful sculptural shapes.

The art of paperfolding is thought to date back to the first or second century AD in China. The Japanese were practising this art by the sixth century and they called it origami (pronounced or-i-GA-me). The word is made up from 'ori', the Japanese word for folding, and 'kami', the word for paper.

In Japan, paper was scarce long ago, so only wealthy people could afford to do paperfolding. But as easier methods of papermaking were developed, paper became less expensive and paperfolding became a popular art for everyone.

The Japanese were not the only people folding paper. The Moors from North Africa were also practising this art. Their religion forbade the creation of representational figures, so their paperfolding took the form of geometric decorative designs, and they took their techniques with them when they invaded Spain during the eighth century. From there, paperfolding spread to South America, then to other parts of Europe as trade routes opened up, and later it spread to the United States. In Victorian England, it became a popular children's pastime. Paper hats, similar to the square hat worn by the carpenter in Lewis Carroll's *Alice Through the Looking Glass*, were made.

In this section you begin with basic scoring and folding techniques, then go on to enjoy making a pirate hat, a glider plane, an animal mask and many other exciting projects. You can also have fun designing and creating your own ideas. Be inventive by using different textured paper like thin corrugated card, brown wrapping paper, metallic and handmade paper. Or try using patterned paper such as gift wrap, wallpaper or pages from a magazine.

With paperfolding you can create wonderful greetings cards for your friends and family and design interesting gift wrap for a special present. So, have fun – and happy paperfolding!

Techniques

There are several basic paperfolding techniques. Freehand folding is simply folding paper without scoring or measuring the paper or card. To create intricate shapes it is helpful to score the paper or card first with a blunt instrument. Folding away from you makes a valley fold. Folding towards you makes a mountain fold. These are shown in the patterns as dots and dashes for valley folds, and dashes for mountain folds (see page 156).

Scoring straight lines

Place a ruler on the piece of card, where you want the line to be. Use the ruler as a guide and run an empty ballpoint pen along the edge to make an indent in the paper.

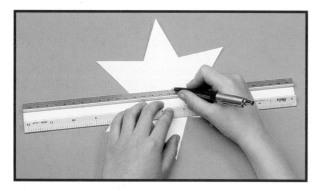

Hard-folding

Fold the card over along the line you have scored. To hard-fold, use the side of your finger-nail to make a neat fold along the scored line.

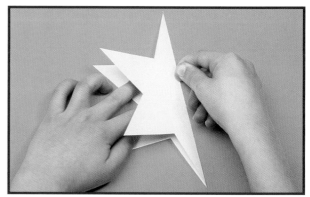

Scoring curves

Cut out a cardboard template of the shape you need. Run an empty ballpoint pen along the edge of the template to make an indent in the paper. Alternatively, you can score a curve freehand.

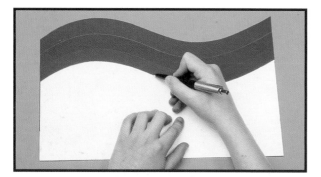

Soft-folding

Gently pinch along the scored line with your fingers. Repeat several times.

Making a template

1 Place a piece of tracing paper over the pattern (see pages 156–159). Tape it down with small pieces of masking tape. Trace around the outline using a pencil. You can use a ruler if the pattern has straight lines. Remove the tape from the tracing paper.

2 Place a piece of carbon paper face down on the surface you want to transfer the design on to. Place the tracing over the top then tape it in place.

3 Trace around the outline with a pencil. Again, use a ruler for any straight lines.

4 Remove the tracing paper and carbon paper to reveal the transferred image.

Pirate Hat

This project only requires simple freehand folding and it is an age-old favourite. It was popular with Victorian children when they played at being pirates. The hat can be embellished by attaching cut-out designs, such as a skull and crossbones, or you could attach a feather if you want to make a Robin Hood hat.

YOU WILL NEED

Black paper
Thin metallic card
Tracing paper • Carbon paper
Masking tape • Pencil
Scissors • Craft knife
Cutting mat • PVA glue

 Take a piece of black paper, the same size as an unfolded tabloid newspaper, and hard-fold it in half lengthways (see page 136).

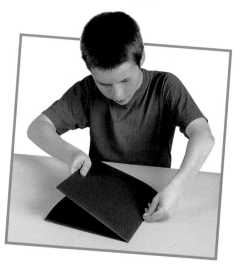

 Hard-fold the paper in half lengthways again.

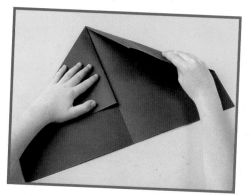

 Fold up the bottom edge nearest to you so that it meets the corners. Fold it up the same amount again. Turn the hat over and repeat on the other side.

3 Open up the last fold, then fold down the left-hand corner to the centre line. Repeat with the other corner.

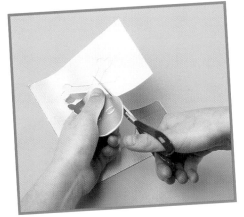

5

Trace the skull and crossbones pattern shown on page 159 on to metallic card (see page 137). Use scissors to cut out the main shape, and a craft knife to cut out the small shapes inside.

(!) Craft knives are very sharp. Ask an adult to cut out the small shapes.

6

Fold the skull and crossbones in half lengthways, then glue it to the front of the hat, making sure that it lies over the central fold.

FURTHER IDEAS

Make a Robin Hood hat using different coloured paper. Using scissors, cut out a feather shape from card, score it down the middle then cut lots of slits in it.

Glider Plane

Your mother or father may have folded wonderful paper aeroplanes for you when you were younger. Well, here is one that you can easily make yourself, using freehand folding, soft-folding and one piece of coloured paper. The plane is decorated with cut-out thin coloured paper shapes which are glued on to the wings. You should never launch your finished plane towards other people.

YOU WILL NEED
Coloured paper
Scissors • PVA glue
Paper clip

1 Cut a piece of coloured paper approximately 25cm x 28cm (8½in x 11in). Score and soft-fold it in half lengthways (see page 136), then fold the top corners down to the centre line.

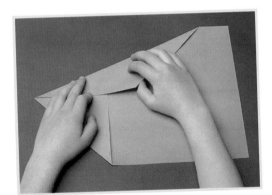

2 Fold each side in from the point, to meet the centre line.

3 Fold the tip back towards the middle, to the point where the sides meet to form the front of the plane.

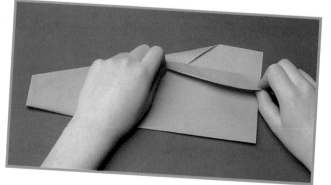

4 Fold the plane in half lengthways, then fold the top wing down about 1cm (½in). Turn the plane over and repeat on the other wing.

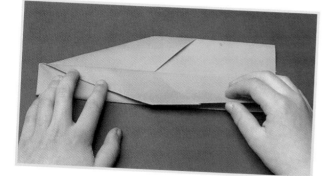

5 Fold the wing down again, from the top of the nose. Turn the plane over and repeat on the other wing.

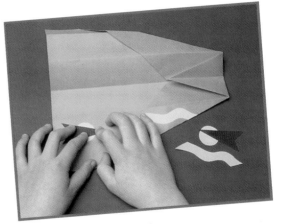

6 Flatten the plane out. Cut out your own decoration from coloured paper, then glue the shapes on to the wings.

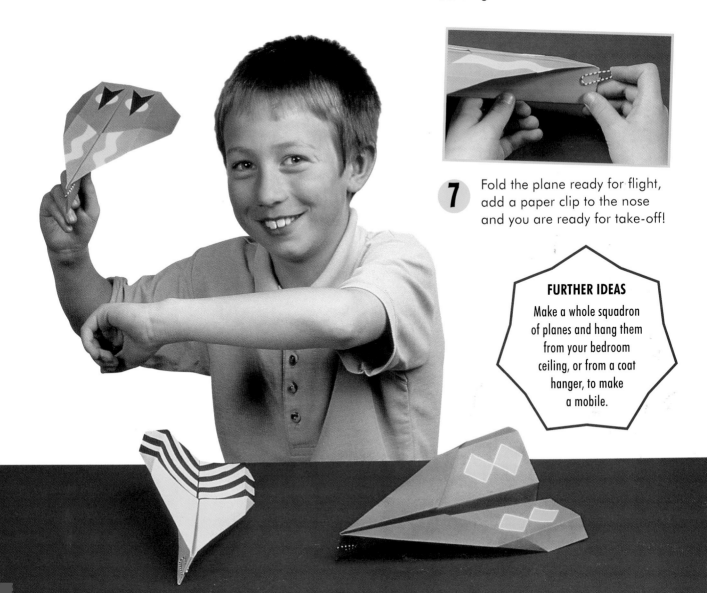

7 Fold the plane ready for flight, add a paper clip to the nose and you are ready for take-off!

FURTHER IDEAS
Make a whole squadron of planes and hang them from your bedroom ceiling, or from a coat hanger, to make a mobile.

Spinning Windmill

This simple design is made from brightly coloured thin card and decorated with different size dots in a contrasting colour. When the windmill spins, it forms wonderful coloured patterns. The handle is made by scoring lines along a length of thin card which is folded into a triangular stick.

1 Cut out a piece of coloured paper approximately 20cm (8in) square. Cut out some shapes from a different coloured paper and glue them on to the square.

2 Use a ruler and pencil to draw two diagonal lines through the square to form a cross. Make a cut at each corner, exactly one third of the way along the pencil line.

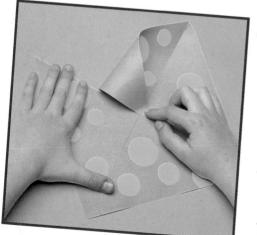

3 Pull one of the points down just past the centre and glue it in place. Hold it for a few moments until it is dry. Repeat with the other three points.

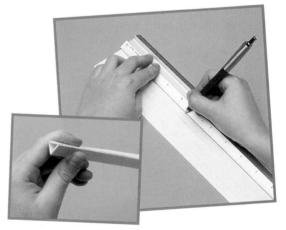

4 Cut out a rectangle of thin card, 4cm x 30cm (2in x 11¾in). Mark and score three lines 1cm (½in) apart. Fold along the lines, then form the card into a triangular stick. Glue in place and hold until dry.

5 Use a craft knife to cut a very small slit in one end of the stick approximately 2cm (¾in) from the end. Make sure that it goes all the way through to the other side. Using scissors, cut a small hole in the centre of the windmill; push a split pin through it, then through the paper stick.

6 Carefully fold back the ends of the split pin, so that the windmill can turn.

FURTHER IDEAS

Make some colourful miniature windmills, tape them to cocktail sticks, then display them in a small vase or container.

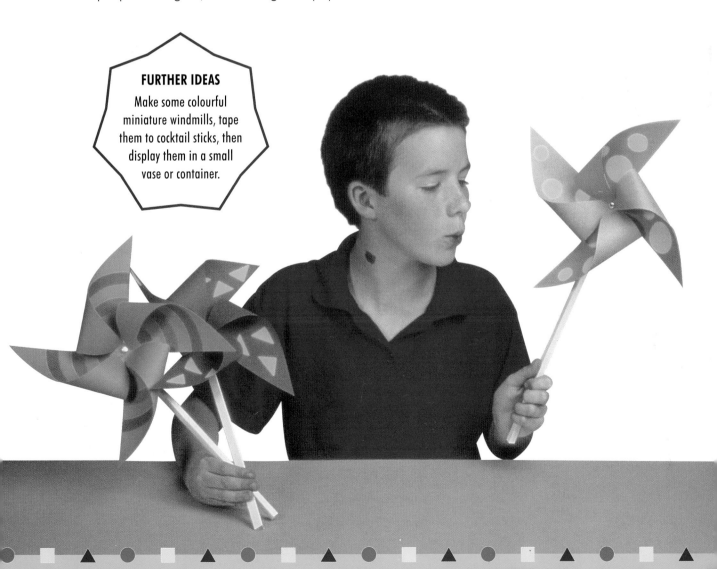

Twisted Pot

With simple folds you can create some colourful crazy containers – and this ingenious little twisted pot is a wonderful example of cardboard engineering. You can decorate it with paper shapes, then fold and glue it to form a square box shape. With a simple twist it suddenly springs to life.

 1 Transfer the design shown on page 158 on to thin coloured card (see page 137). Cut out the rectangular shape. Score the card along the vertical and diagonal lines using an empty ballpoint pen and a ruler (see page 136).

2 Cut out shapes of your choice from coloured paper.

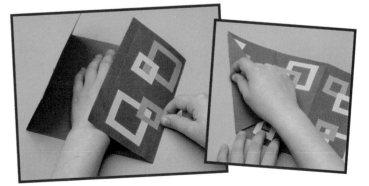

3 Use PVA glue to stick the paper shapes to the card. Leave to dry.

4 Hard-fold along all of the scored lines (see page 136). Turn the card pattern face-down and fold the vertical lines towards you. Turn the card over then fold the diagonal lines towards you.

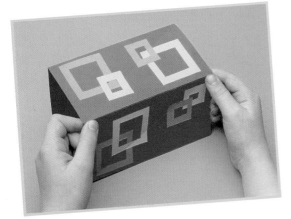

 Glue the flap to the other end to form an open-ended box. Hold between your finger and thumb for a few moments, then leave to dry thoroughly.

6 Flatten the box. Slowly push your thumbs together, then very gently twist your right hand towards you so that the pot springs into shape.

FURTHER IDEAS
You could make a set of small brightly coloured pots which can be used as egg cups for the whole family.

Bat Mobile

This fun mobile uses black and contrasting metallic card, so that when the stars and moon turn they reflect the light beautifully. The shapes are traced from the patterns, cut out and scored to create a three dimensional image. They are then suspended by thread on a coat hanger, but you could use an ordinary wooden stick or a wire rod.

YOU WILL NEED

Black and thin metallic card
Tracing paper • Carbon paper
Masking tape • Pencil
Scissors • Empty ballpoint pen
Ruler • Sharp pencil
Cotton thread • Clear sticky tape
Coat hanger

1 Transfer the bat, moon and star patterns from page 157 on to black and thin metallic card (see page 137). Cut out the shapes.

2 Score and then hard-fold the stars (see page 136) then open them up to form three-dimensional forms.

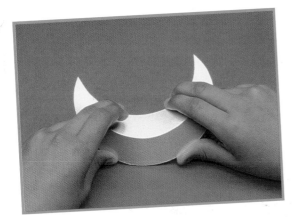

3 Score along the curved centre line of each moon and then soft-fold gently (see page 136).

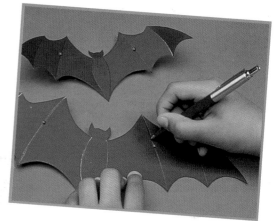

4 Score each bat freehand, then soft-fold to give shape to the body and wings.

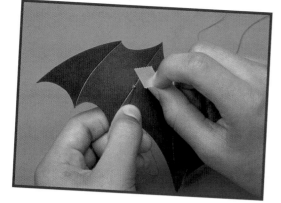

5

Thread lengths of cotton through the holes and secure on the underside with clear sticky tape.

Ask an adult to help you suspend your mobile from a suitable location.

Note You can adjust the way your mobile hangs by adding small pieces of removable adhesive to the pieces.

6

Tie the cotton on to a coat hanger to suspend the moon, stars and bats at different levels. Snip off any loose ends.

FURTHER IDEAS

You could cover the coat hanger with crepe paper. Decorate it with cut-out cloud shapes or shiny stars.

Pleated Picture Frame

Every artist needs a beautiful frame for a favourite picture or painting. It completes the effect and complements the image it surrounds. This project shows you how to create a simple pleated frame. The sides are glued on to a corrugated cardboard base and pleated corners are added in a contrasting colour.

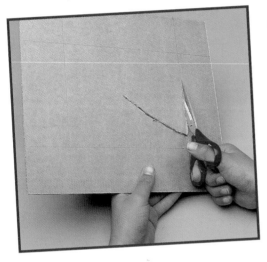

 Cut out a piece of corrugated cardboard 22cm x 25cm (8¾in x 10in). Draw a line 5cm (2in) in from each edge with a ruler and pencil. Cut out the centre to form a frame.

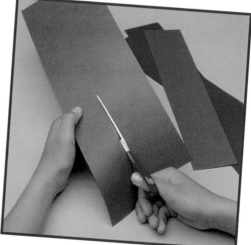

 Cut out 2 strips of thin coloured card 6cm x 30cm (2¼in x 11¾in) and 2 strips 6cm x 27cm (2¼in x 10¾in).

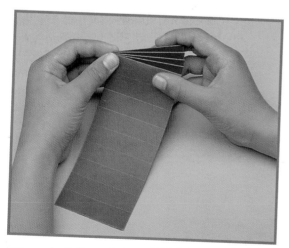

3 Mark lines 1.5cm (⅝in) apart all along each strip of coloured card. Pleat each strip by scoring and then hard-folding along the lines (see page 136).

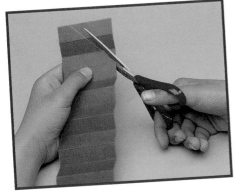

Open the pleated strips out. Mark a diagonal line from the third fold approximately 1cm (½in) in from the corner. Cut the corner off. Repeat on all ends of the coloured card strips.

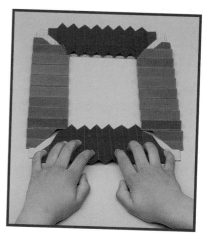

6

Transfer the pattern on page 157 on to coloured card four times (see page 137). Cut them out, score and pleat them, then glue them on to each corner to hide the joins.

5 Apply glue to the cardboard base, then position the pleated strips on top. Leave to dry.

FURTHER IDEAS
You can use circles or other shapes on the corners, and experiment with different sized pleats to create different effects.

Bird and Worm Card

It is always nice to receive and send homemade cards. This pop-up card will amuse your family and friends and it can be used for any occasion. It uses a simple fold to create the pop-up action. The bird's head is transferred from the pattern and glued to the card. A slit is then cut along the beak and folded back. For the finishing touch a pink worm is added to the inside of the beak.

YOU WILL NEED

Coloured paper
Thin card • Scissors
Tracing paper • Carbon paper
Masking tape • Pencil
PVA Glue

 Transfer the bird and worm patterns on page 157 on to coloured paper (see page 137). Cut out the shapes.

 Cut out a piece of thin card approximately 36cm x 26cm (14¼in x 10¼in). Fold the card in half, and then in half again.

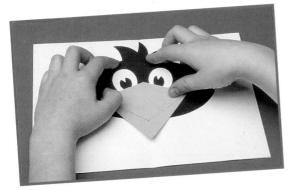

 Unfold the card once and lay it flat, with the first fold at the top. Glue the beak on to the bird, then glue the bird on to the inside of the open card.

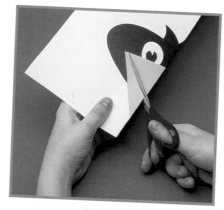

 Open the card up completely. Fold it inside out and cut a slit along the line on the beak.

5 Hard-fold the top of the beak up, and the bottom of the beak back (see page 136).

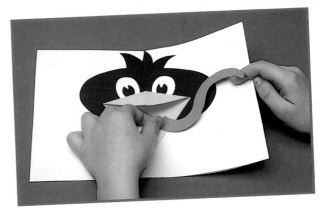

6 Re-fold the card and pull the beak up to open the mouth. Fold the worm over the bottom of the beak and glue it in place inside the mouth.

FURTHER IDEAS

You can adapt the patterns to make other animals. Try making a frog with a fly in its mouth. The worm can become the frog's tongue and you can use tracing paper to make the wings for the fly.

Treasure Chest

Everyone has a collection of different things that they treasure and want to keep safe or hidden away. It could be special pebbles, shiny beads or secret messages. This little treasure chest is just the thing to store them in. It is made to look like the real thing by using a black marker pen to add the bolt heads and a lock.

 Transfer the basic chest pattern on page 156 on to thin coloured card (see page 137). Cut out the shape, then cut along the solid cut lines.

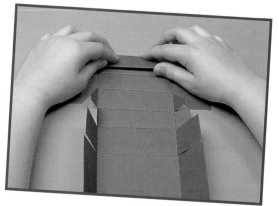

 Score and hard-fold along all the dotted lines (see page 136).

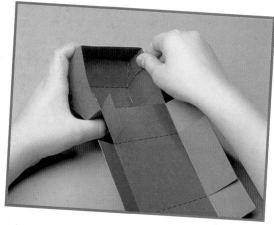

 Glue the back of the angled tabs 1, 2, 3, 4 to the inside of the lid ends. Now glue tabs 5, 6, 7, 8 to the inside of the lid ends in the same way, to complete the lid.

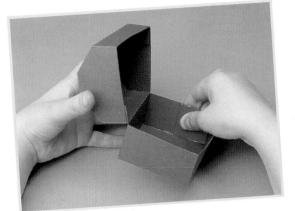

4 Glue the back of the corner tabs 9, 10, 11 and 12 to the inside of the base ends to form a box.

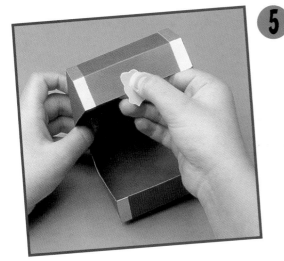

5 Transfer the lock design shown on page 156 on to metallic paper (see page 137). Cut out thin metallic paper strips and then glue the lock and strips on to the chest.

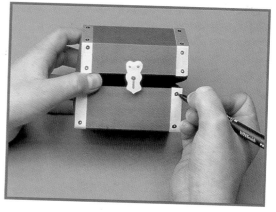

6 Use a black marker pen to add detailing to the lock, and make black circles along the metallic strips to represent bolt heads.

FURTHER IDEAS

Use metallic card and make a shiny treasure chest for your keepsakes, or decorate a coloured chest with interesting shapes.

Elephant Mask

Everyone loves masks. They are great fun to make and wear and they can transform you into something, or someone, completely different. This project is easy to do and it can be adapted if you want to create a different animal.

Ask an adult to help you when you staple. The flat side of the staple must be next to the head.

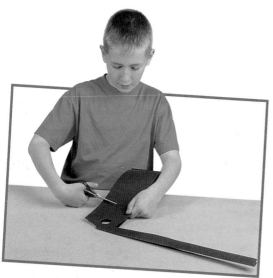

1 Cut out a piece of thin black card approximately 70cm x 50cm (27½in x 19¾in). Fold the card in half widthways, then align the marked edge of the basic mask pattern on page 158 along the fold. Transfer the pattern on to the card (see page 137), then cut out the shapes.

2 Open up the mask and fit the side tabs around your head. Hold them in position, remove the mask then staple the ends. Replace the mask on your head and take the front strip over the top of your head. Hold in position, remove and staple in place.

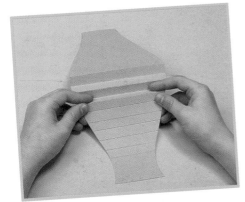

3 Transfer the face, ears and trunk patterns on pages 158 and 159 on to thin coloured card. Cut them out. Score along the fold lines of the trunk (see page 136) and then form it into pleats.

4 Use scissors to cut out the eye holes. Use a craft knife to cut a slit in the face where the trunk goes. Insert the trunk into the slit and tape in place.

Craft knives are sharp. Ask an adult to cut the slit in the trunk.

FURTHER IDEAS
You can adapt the pattern and use different coloured card to make a pig mask.

5 Fold the ears along the fold lines then ask an adult to staple them to the sides of the basic mask.

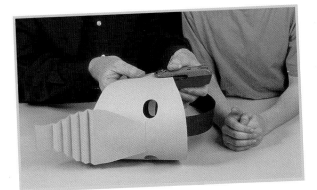

6 Ask an adult to attach the face to the basic mask with staples, making sure the eyes line up.

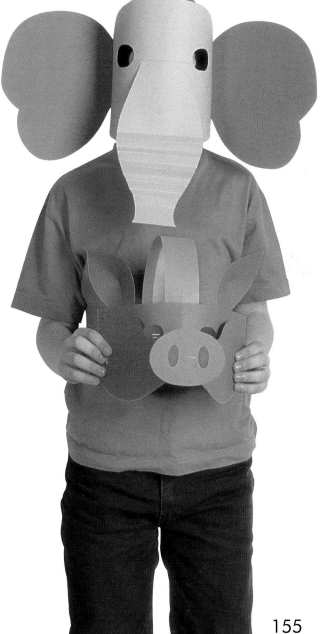

Patterns

Enlarge these patterns on a photocopier by 200%, then use them to make the templates for the projects (see page 137).

The patterns show two types of fold. Sometimes you need to fold the paper away from you. These folds are called valley folds. They are shown as dots and dashes. When you fold towards you, it's called a mountain fold. These folds are shown as dashes.

> ! Get an adult to help you photocopy the patterns.

—·—·—·—·—·—·—·—·— *Valley fold – fold away from you*

---------------------- *Mountain fold – fold towards you*

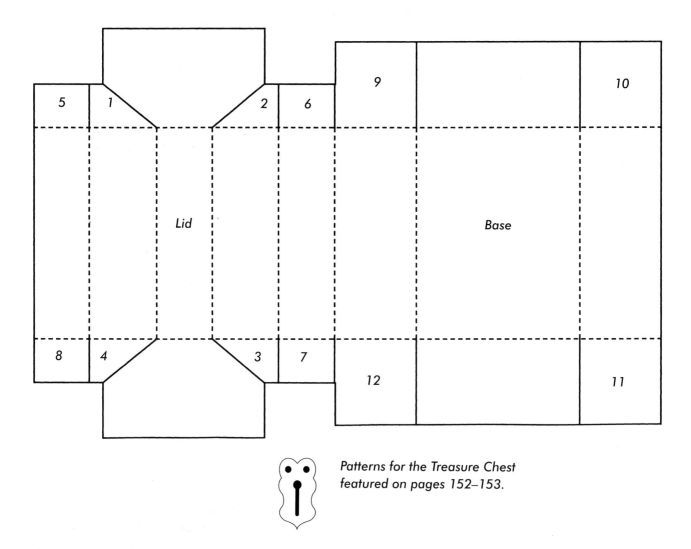

Patterns for the Treasure Chest featured on pages 152–153.

Readers are allowed to photocopy the patterns in this book for their personal use free of charge and without prior permission of the publishers.

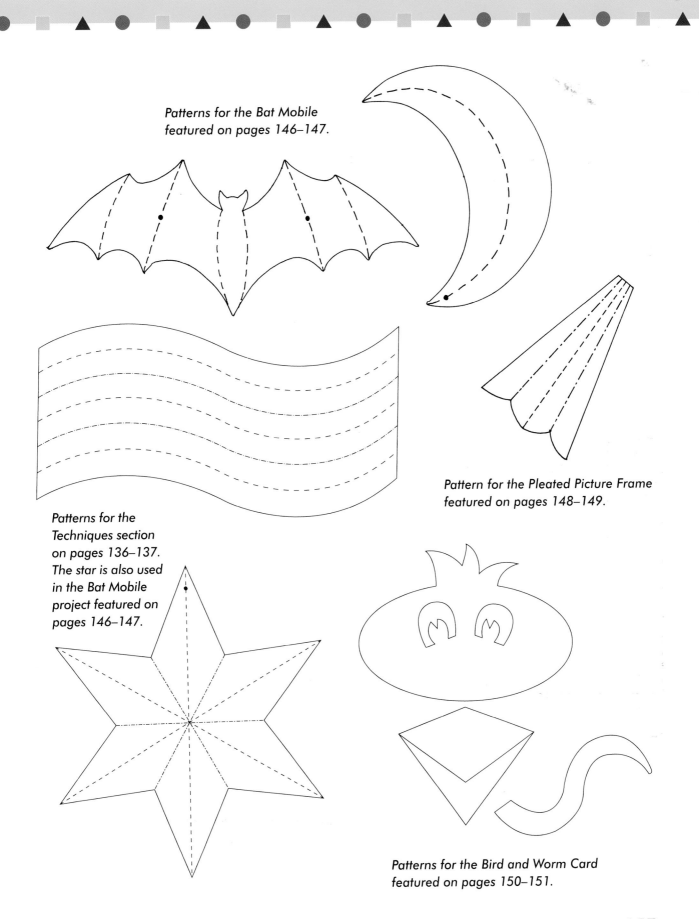

Patterns for the Bat Mobile featured on pages 146–147.

Pattern for the Pleated Picture Frame featured on pages 148–149.

Patterns for the Techniques section on pages 136–137. The star is also used in the Bat Mobile project featured on pages 146–147.

Patterns for the Bird and Worm Card featured on pages 150–151.

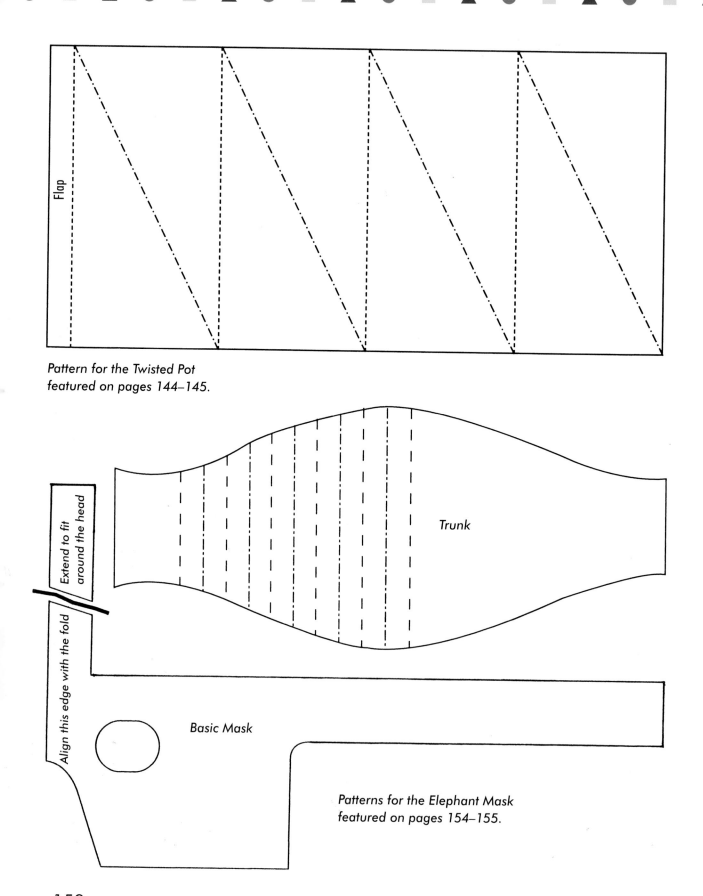

Flap

Pattern for the Twisted Pot
featured on pages 144–145.

Extend to fit
around the head

Align this edge with the fold

Trunk

Basic Mask

Patterns for the Elephant Mask
featured on pages 154–155.

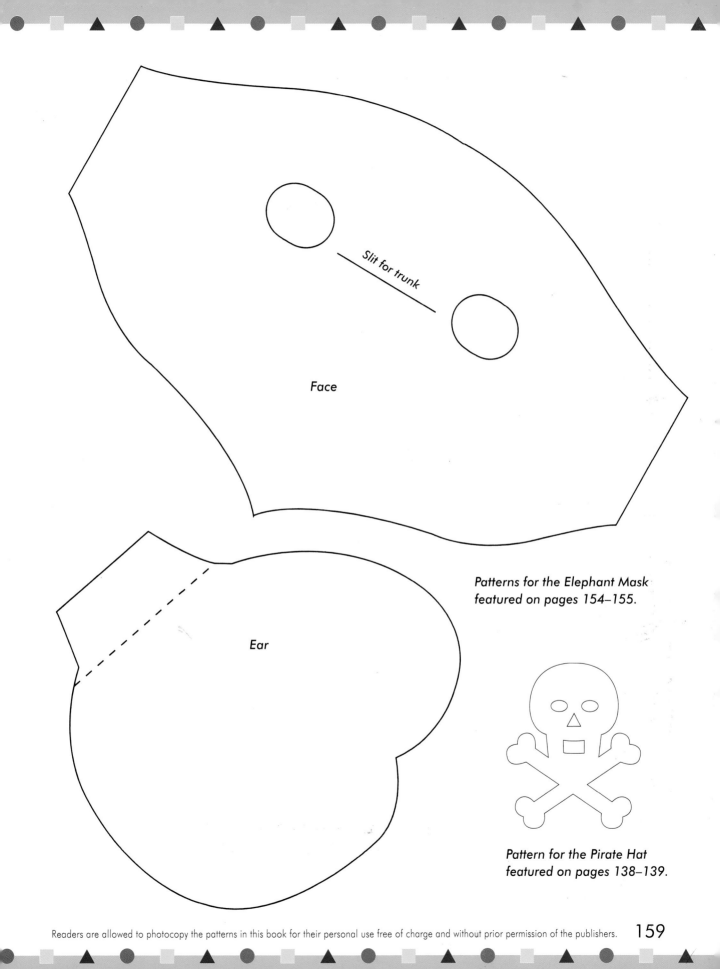

Slit for trunk

Face

Ear

Patterns for the Elephant Mask featured on pages 154–155.

Pattern for the Pirate Hat featured on pages 138–139.

Readers are allowed to photocopy the patterns in this book for their personal use free of charge and without prior permission of the publishers.

About the authors

Judy Balchin studied art at Cardiff College of Art and then specialized in graphic design at Kent Institute of Art and Design. She now designs craft kits for both adults and children, and runs workshops for all ages. Judy has appeared on television as a craft demonstrator and her craft techniques have been featured in three videos. She has written many books and frequently writes articles for art and craft magazines.

Michelle Powell studied art and design at Bath College of Higher Education. She majored in paper making and graduated with a degree in teaching art. Michelle has a passion for paper, beads and fabric and has crafted as long as she can remember. She has worked as a craft product designer and magazine contributor, prior to becoming editor of *Scrapbook Magic* and *Practical Crafts*. Michelle is now a craft designer and author.

Greta Speechley studied at Hornsey College of Art. She worked as a television graphic designer for many years on title sequences, commercials and special effects. Alongside this, she was tapestry weaving, painting, and making ceramics, selling through craft fairs and galleries. She has held many workshops for both children and adults. She is also the author of the 'Crafts for Kids' series of books published in the USA. She teaches A-level Art Textiles and is developing her own storyboard for a children's animation film.

David Watson is an artist who specialises in experimental papermaking techniques and he is the author of *Creative Handmade Paper*, published by Search Press. He carries out regular commissions and has exhibited his work throughout Britain and in the USA. David has been involved in a number of artist-in-residence schemes, many of which were at schools and colleges. He gives demonstrations of his work and conducts workshops for groups of all ages. He also teaches students to degree level. David lives in Brighton. He is an avid collector of discarded and recycled materials which he uses for public art commissions.

Clive Stevens studied art and design in Canada, where he then worked as a graphic designer, art director and illustrator. He ran his own advertising agency in the UK for 20 years. Clive has written four books on paperfolding and paper sculpture. He has run weekend courses in paper sculpture and written articles on paperfolding techniques for *Crafts Magazine* and *The Artist*. He has also produced paper sculpture animations for television advertising. He presently creates paper sculptures for sale throughout the world, and travels around British schools demonstrating paper crafts.